Bosch/Bruegel

HARCOURT BRACE JOVANOVICH MASTERS OF ART SERIES

Harcourt Brace Jovanovich, Inc. New York

Text and design by the staff of Tokyo International Publishers, Ltd.

Copyright © 1967 by Kawade Shobō and The Zauho Press
English translation copyright © 1971 by Tokyo International Publishers, Ltd.

ISBN 0–15–113600–9
Library of Congress Catalog Card Number: 75–161094
Printed in Japan

CONTENTS

Photographed by

Museo del Prado (plate 1, 2, 6, 12, 13, 14, 25, 26, 27, 28, 29, 30, 37, 54, 55, 56) Staedelsches Kunstinstitut, Frankfurt (4) Museum Boymans-van Beuningen Rotterdam (5, 10, 32, 33, 34, 35, 36) Kunsthistorisches Museum, Wien—Meyer Erwin Photograph (7, 42, 43, 44, 48, 49, 50, 53, 58, 59, 60, 61, 63, 64, 67, 68, 69, 70, 71, 72, 74) Kunstund Museumsbibliothek der Stadt Köln (8) The National Gallery, London (9) Staatliche Museen Berlin, Gemäldegalerie Dahlem (11, 45, 46, 47) René Roland (15, 16, 17, 18, 19) Gemäldegalerie der Akademie der Bildenden Künste in Wien—Edeltraut Mandl (20, 21, 22, 23, 24) Bayerische Staatsgemäldesammlungen, München—Firma Joachim Blauel (31, 57, 65) José Lazaró—David Manso (38) Rijksmuseum, Amsterdam (41) Museum voor Schone Kunsten, Gent (39, 40) The Metropolitan Museum of Art (62) Photographie Giraudon (3, 51, 52, 73) Zauho Press (66)

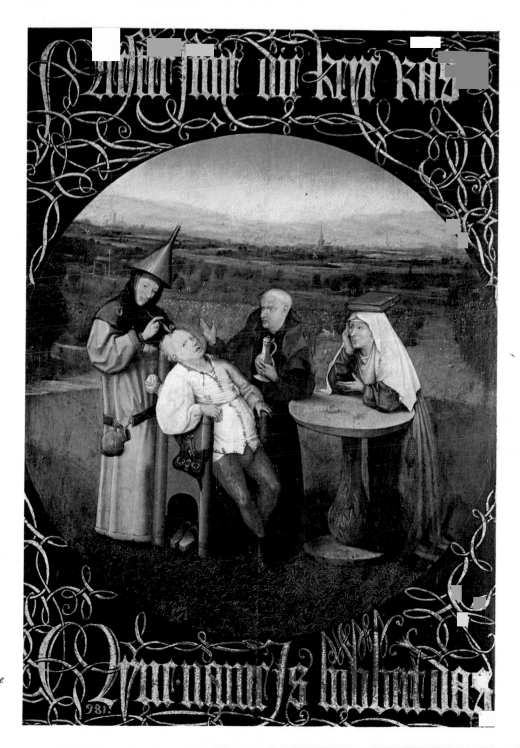

1 Bosch *The Cure
 of Folly* 1475–
 1480

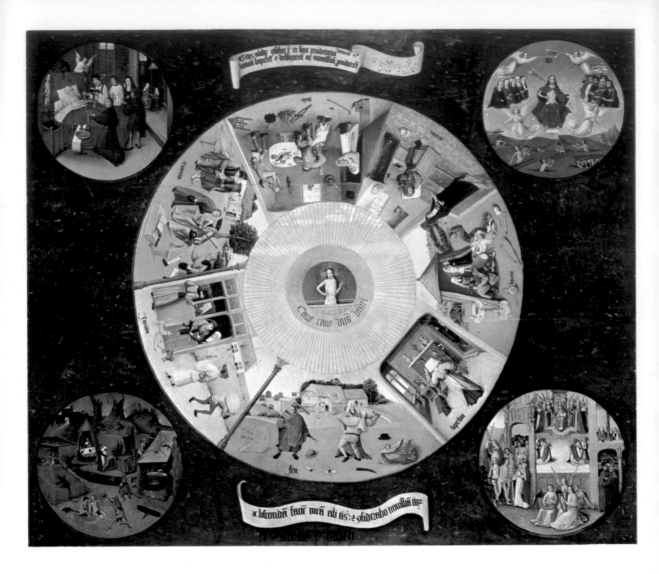

2 Bosch *The Seven Deadly Sins* 1475–1480

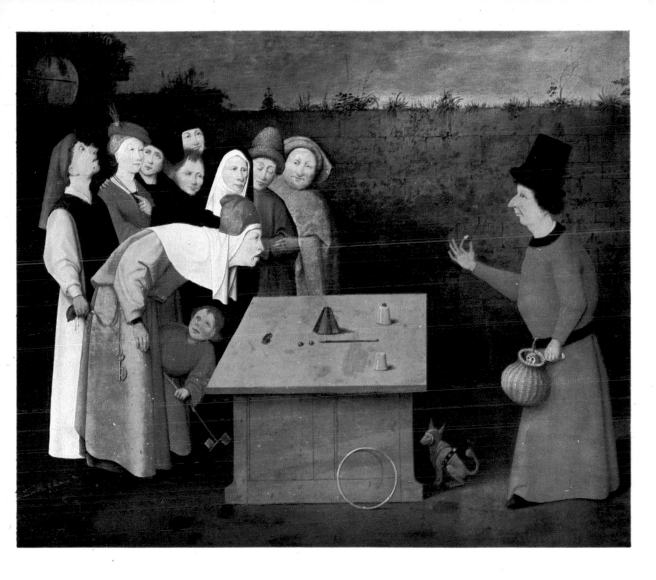

3 Bosch *The Conjuror* 1474–1480

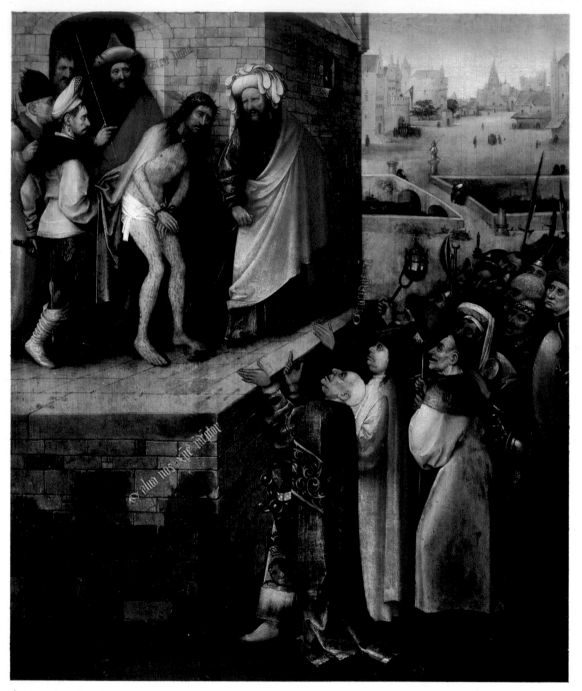

4 Bosch *Ecce Homo*

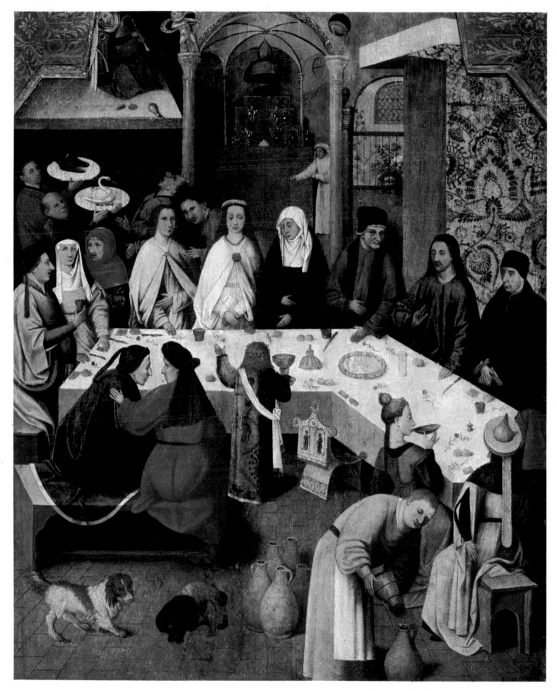

5　Bosch　*The Marriage at Cana*

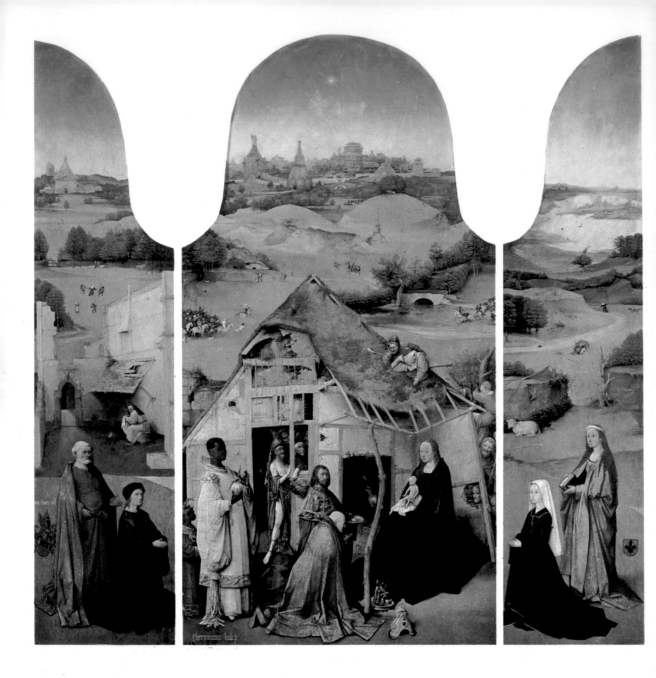

6 Bosch *The Adoration of the Magi*

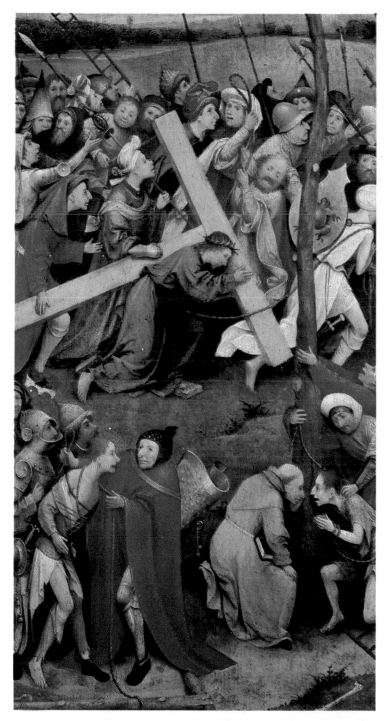

7 Bosch *Christ Carrying the Cross*

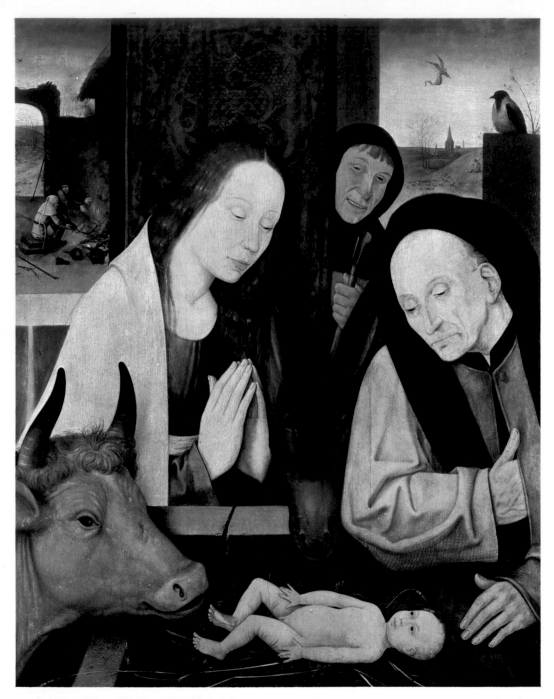

8 Bosch *The Adoration of the Shepherds*

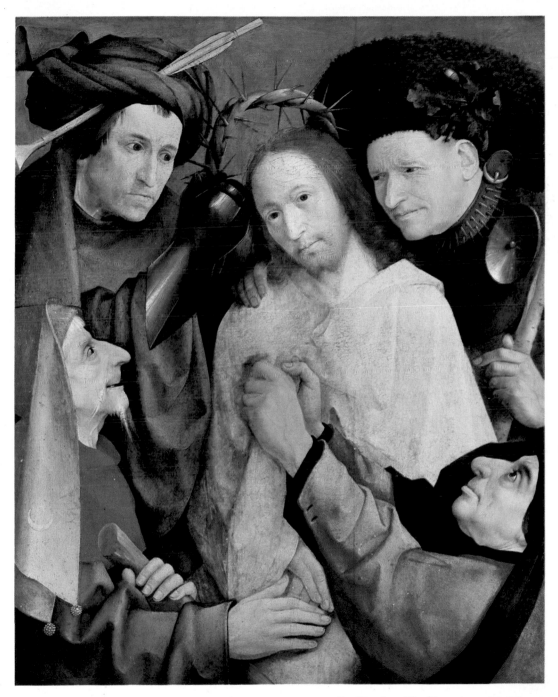

9 Bosch *The Crowning with Thorns*

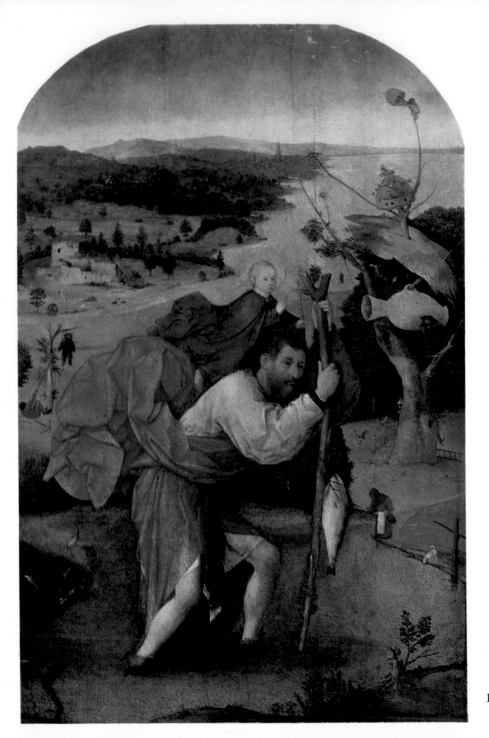

10 Bosch *Saint Christopher*

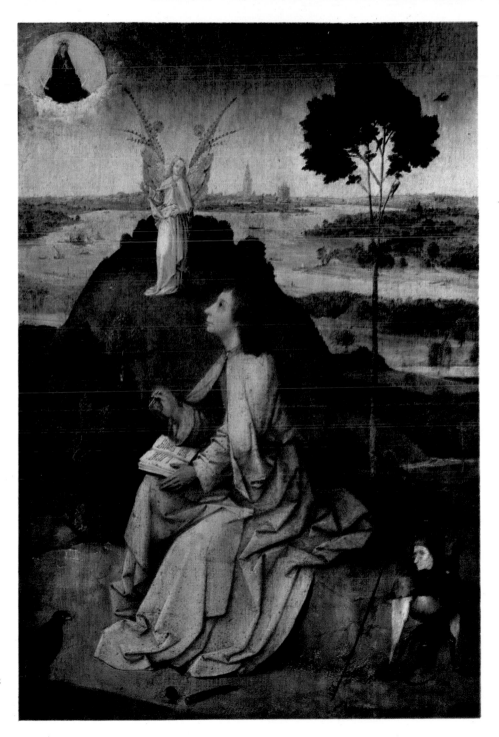

11 Bosch *Saint John
the Evangelist in
Patmos*

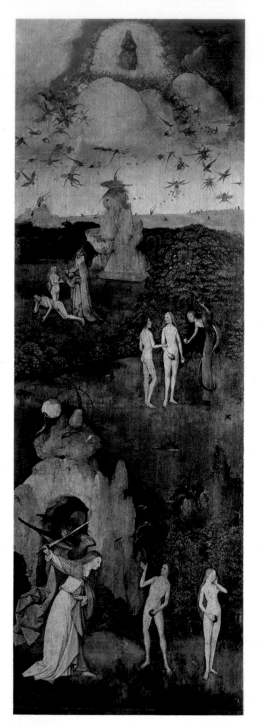
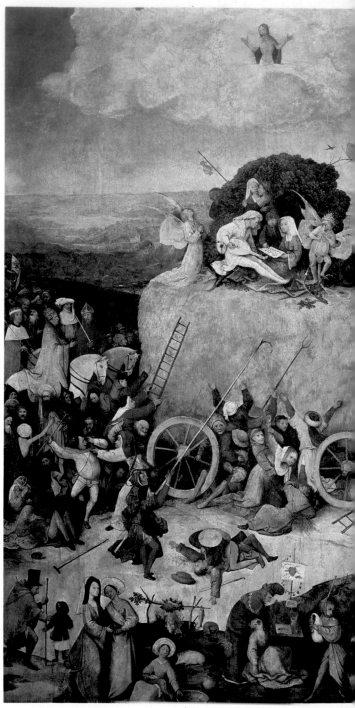

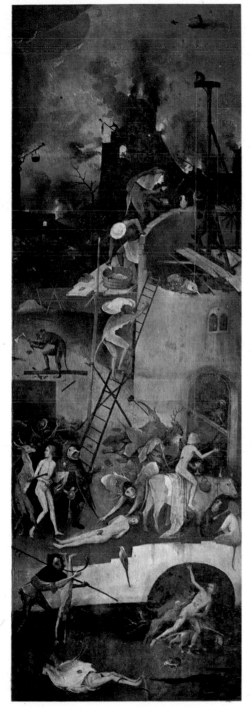

12–14 Bosch *The Haywain* 1480–1485

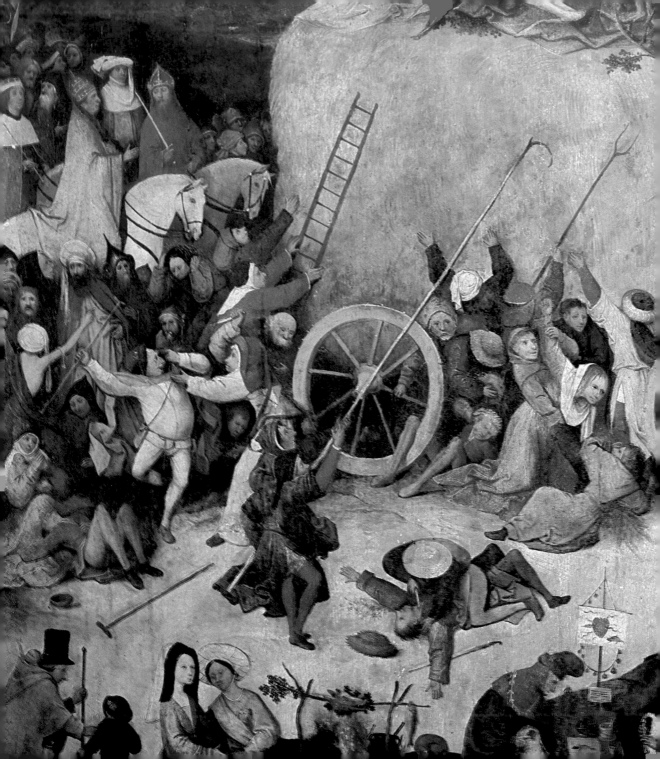

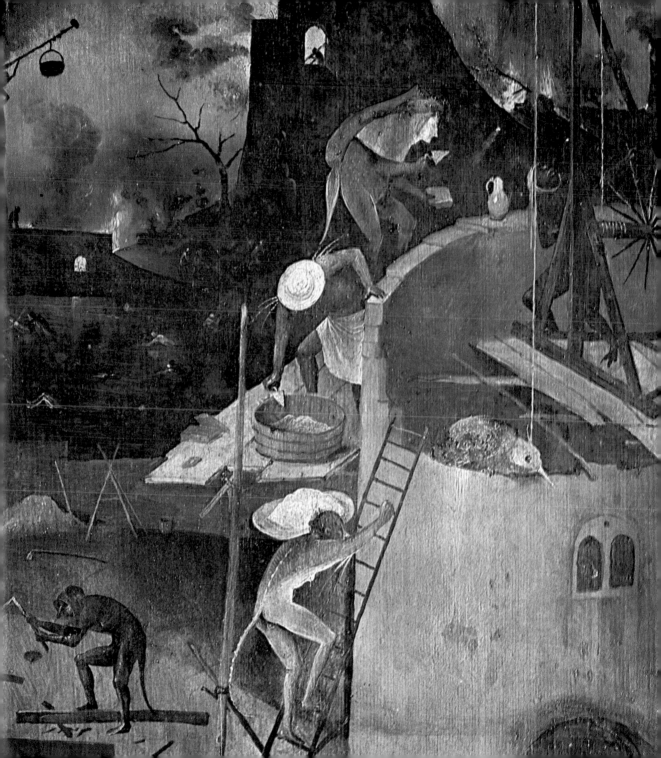

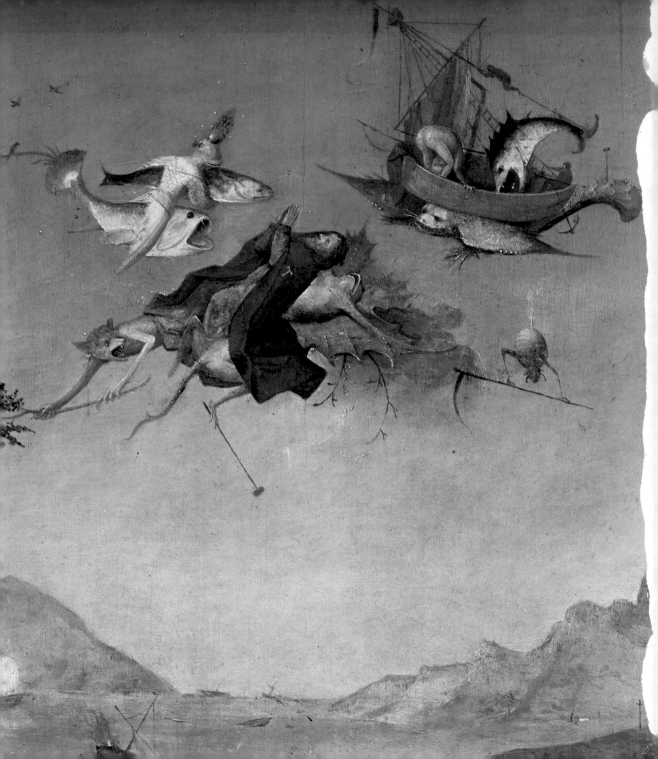

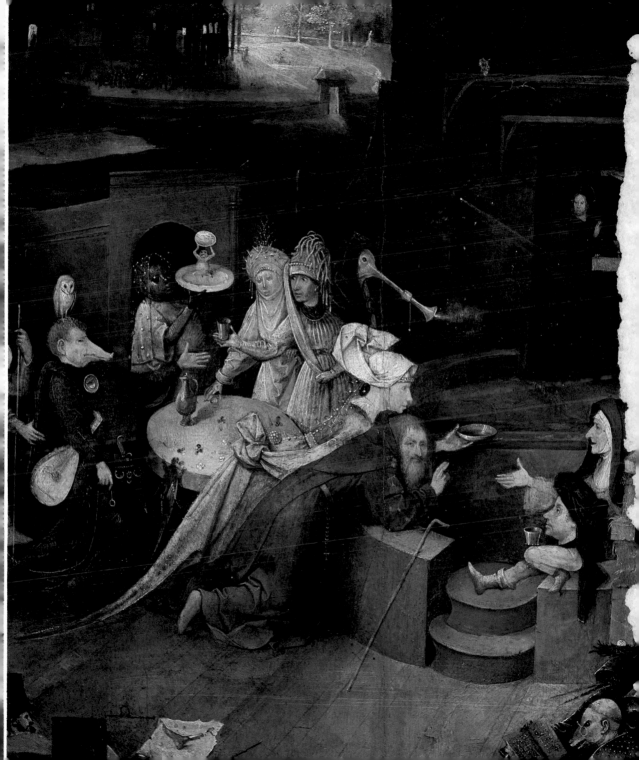

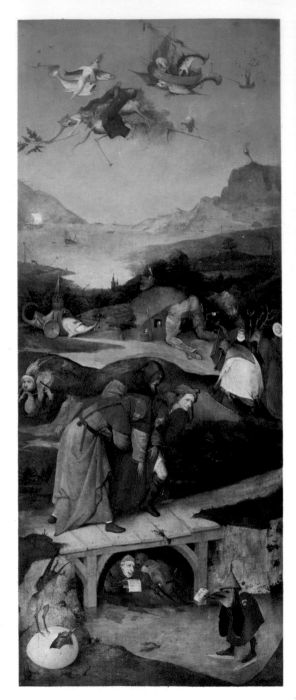
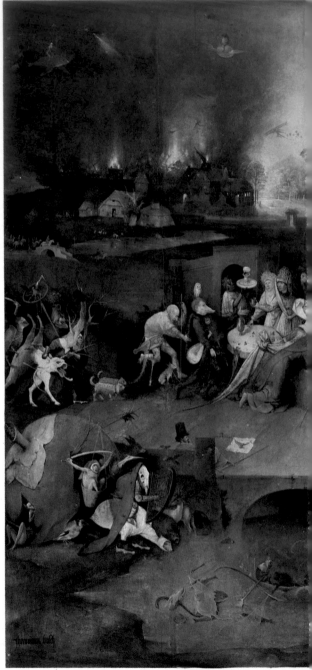

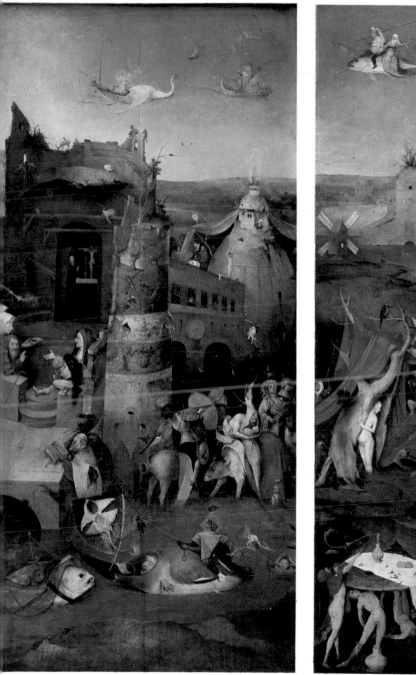
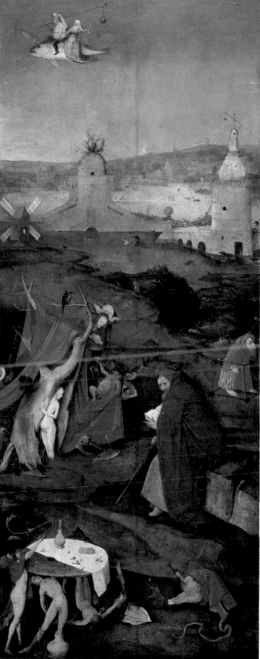

15–19 Bosch *The Temptation of Saint Anthony* *Circa* 1500

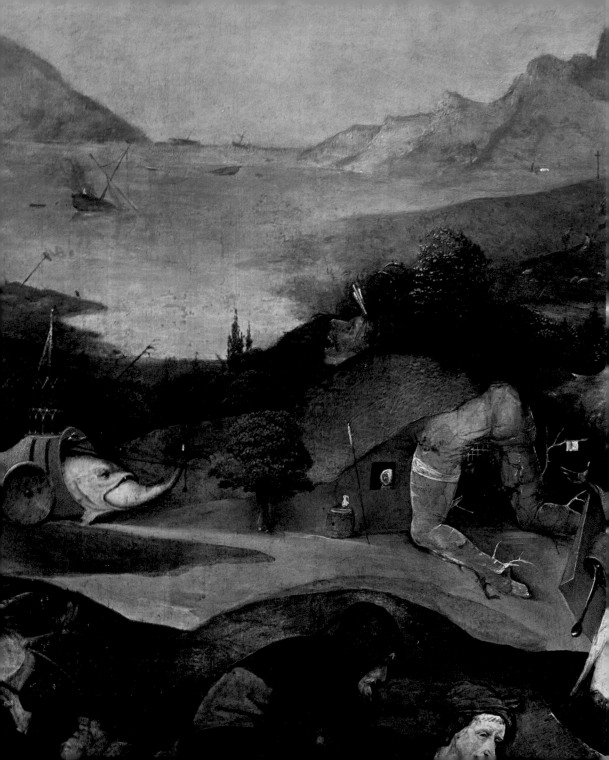

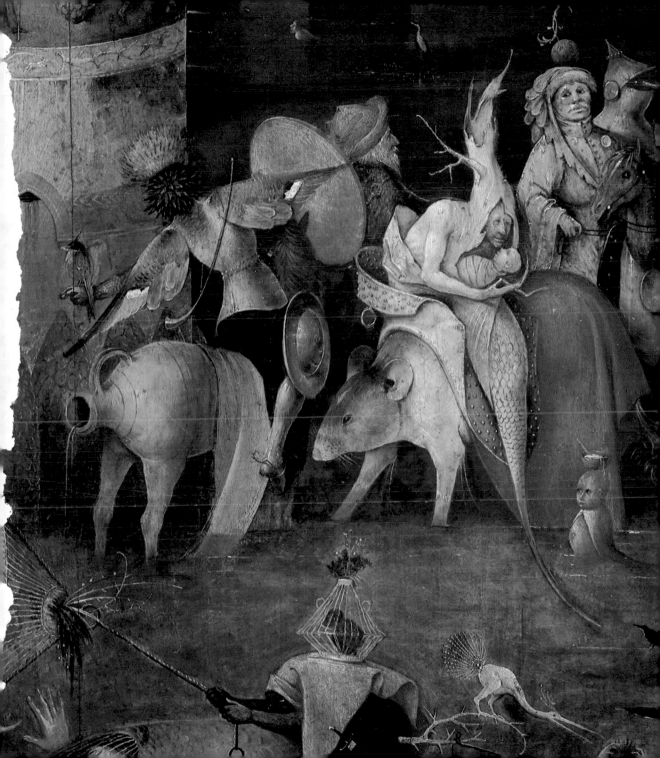

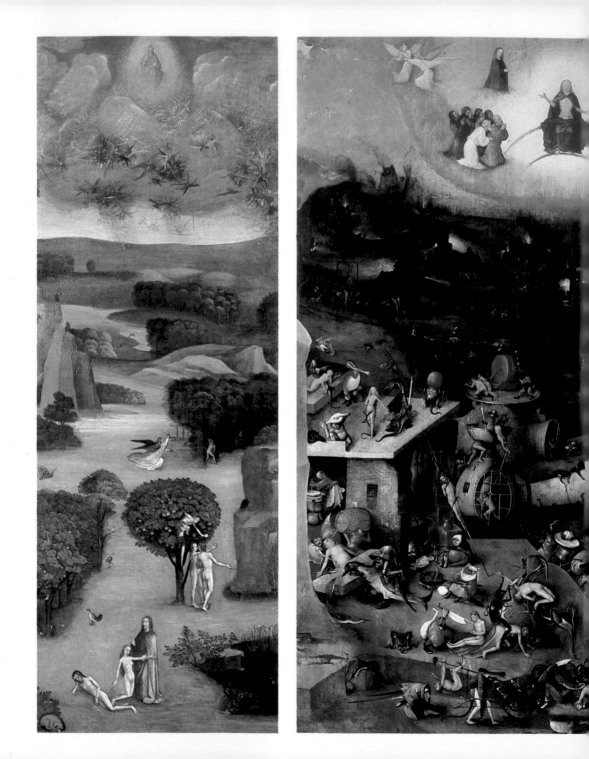

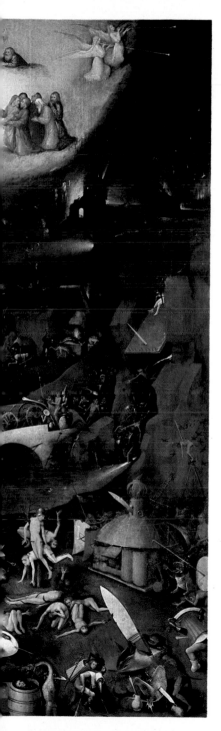

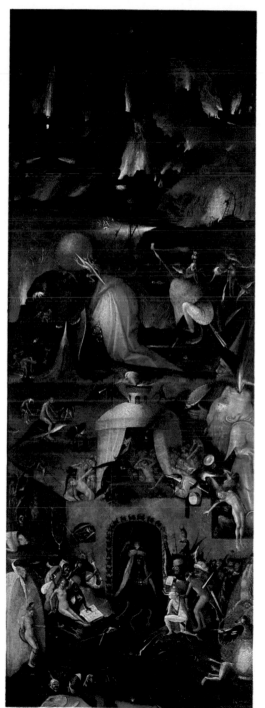

20–24 Bosch *The Last Judgment*

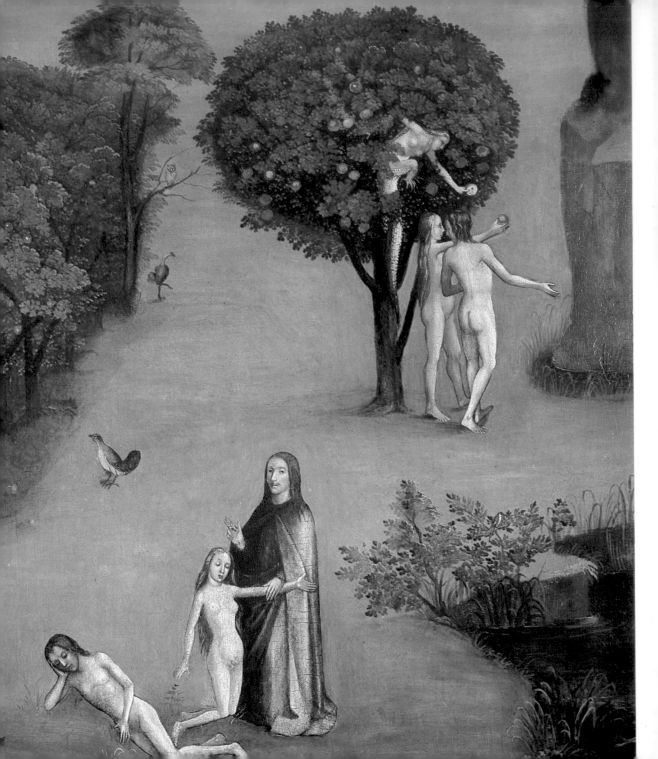

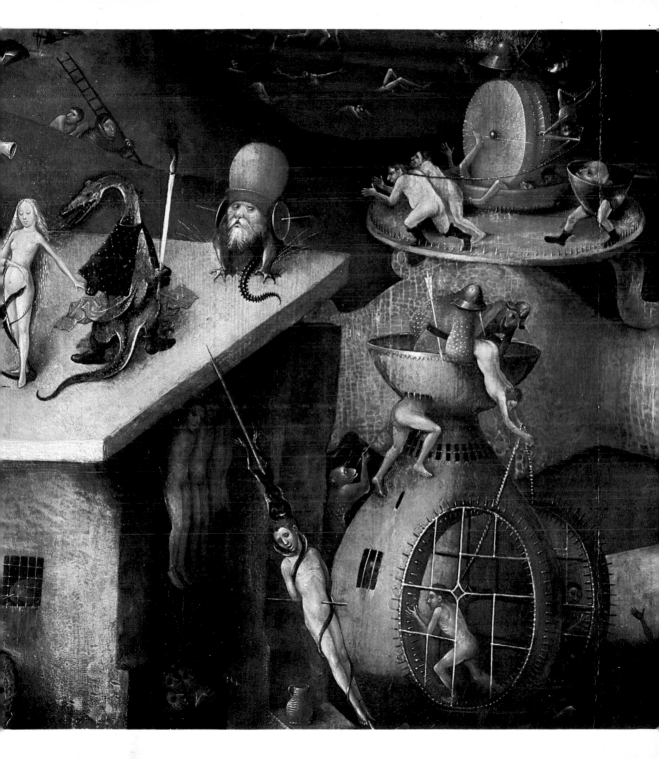

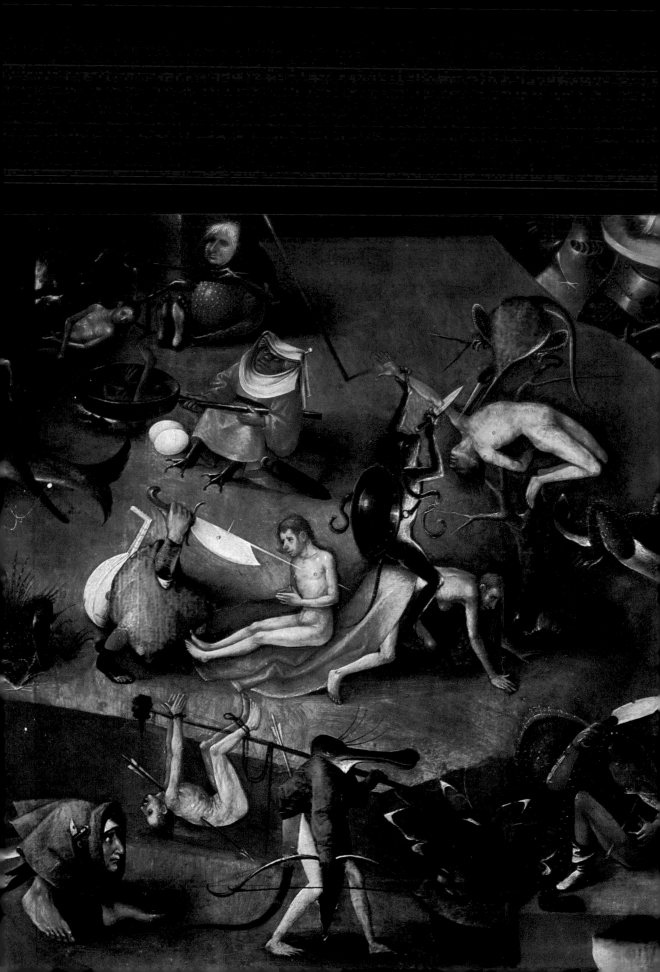

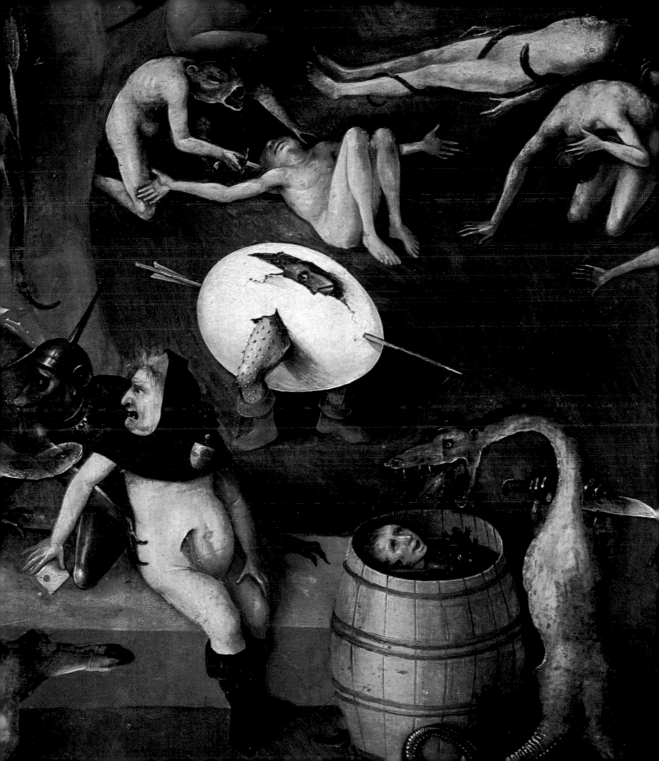

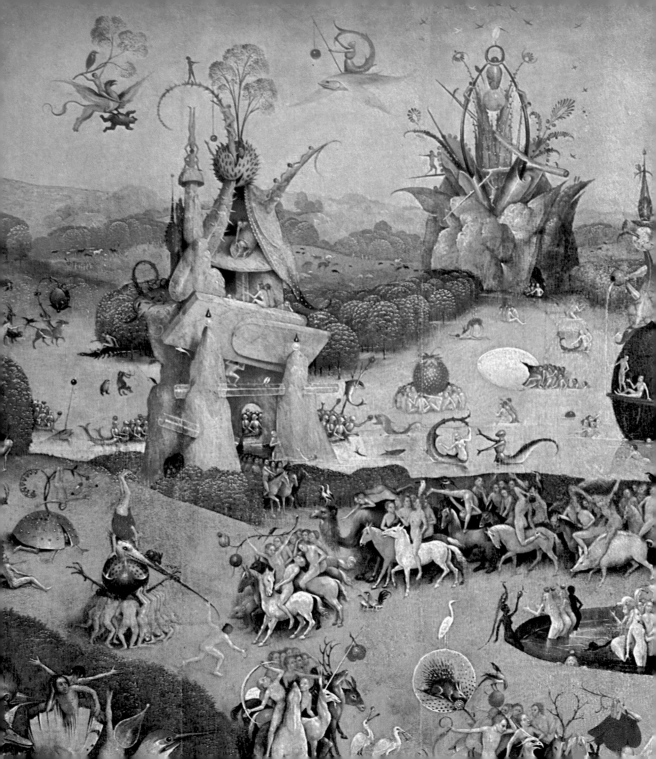

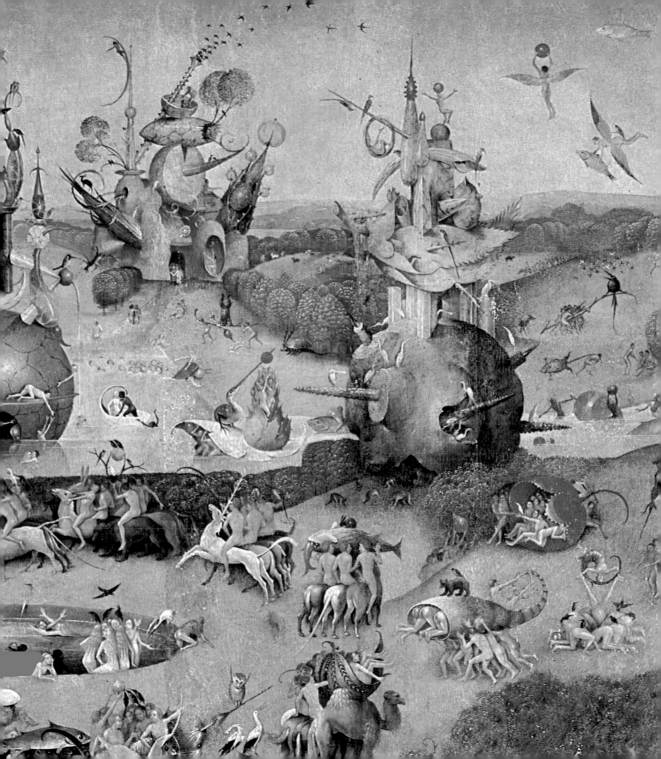

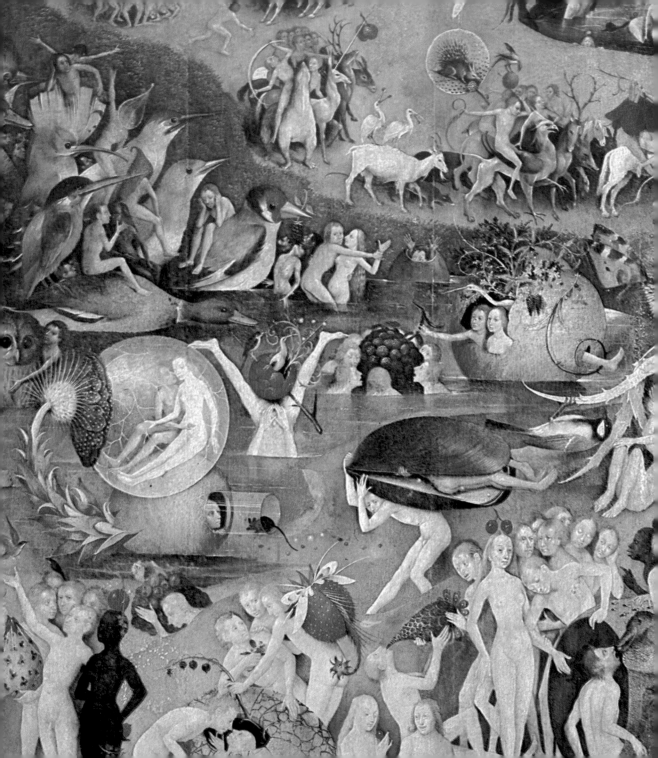

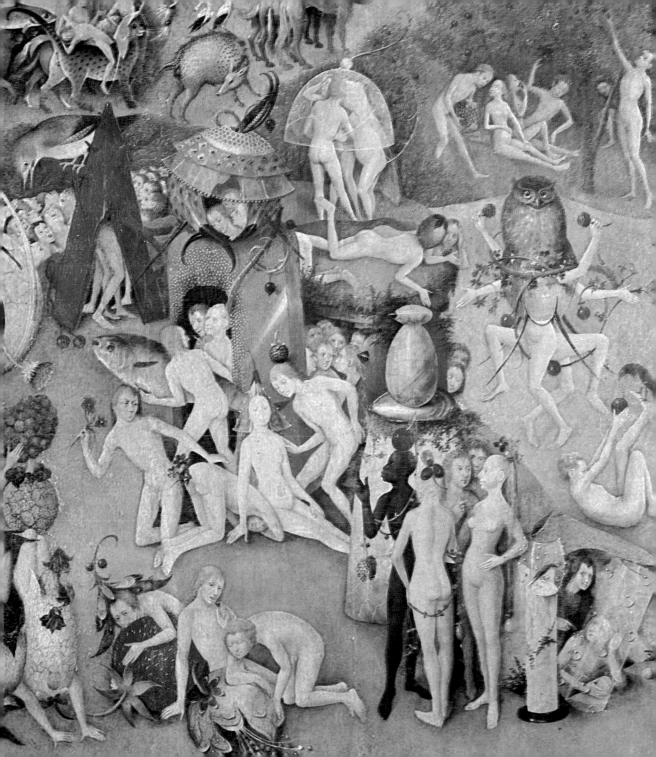

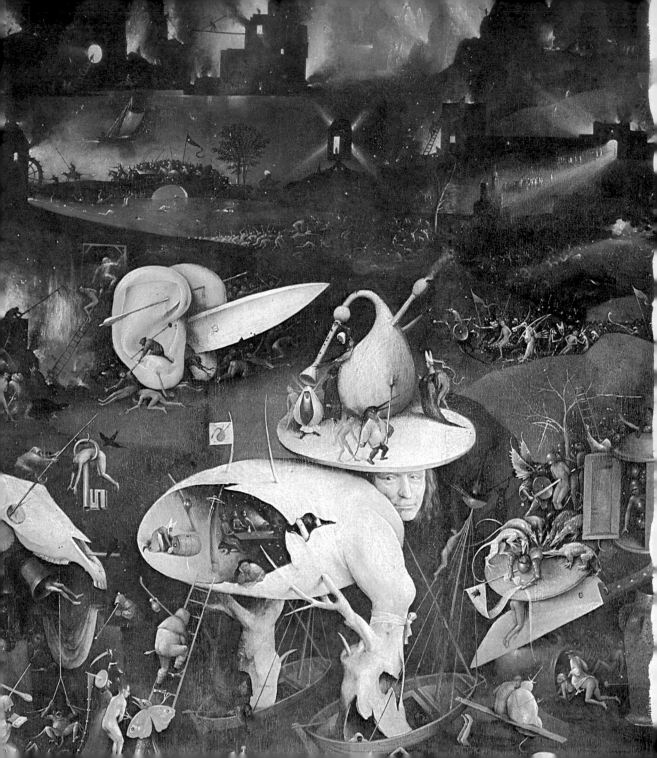

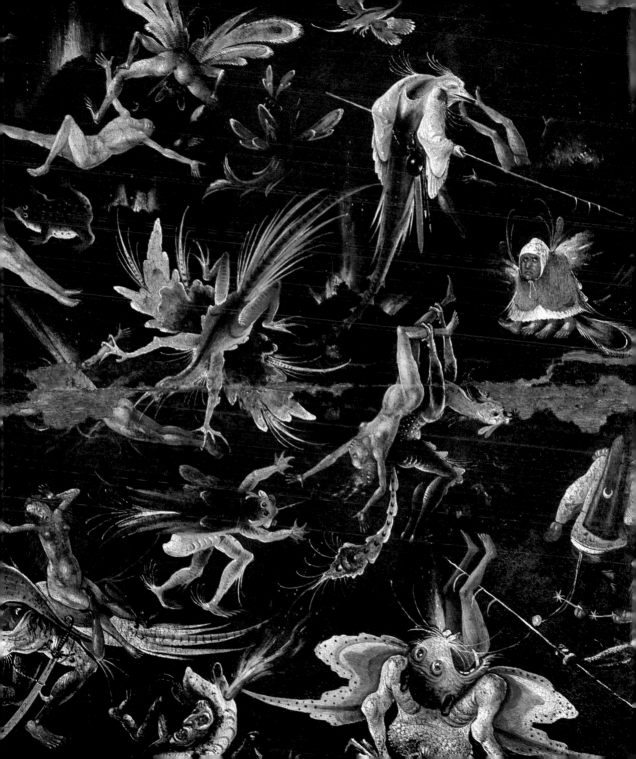

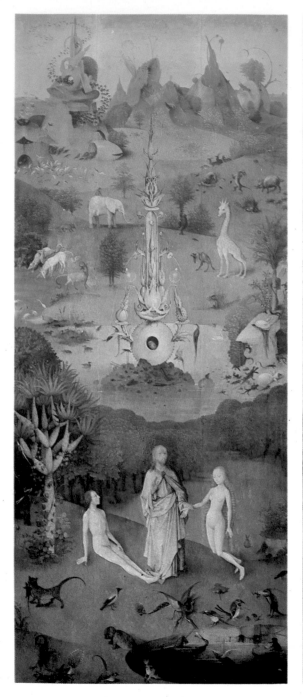
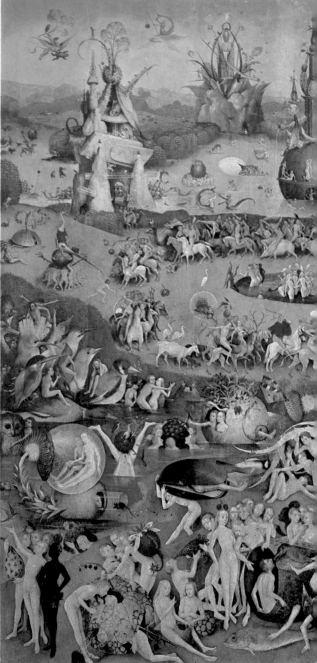

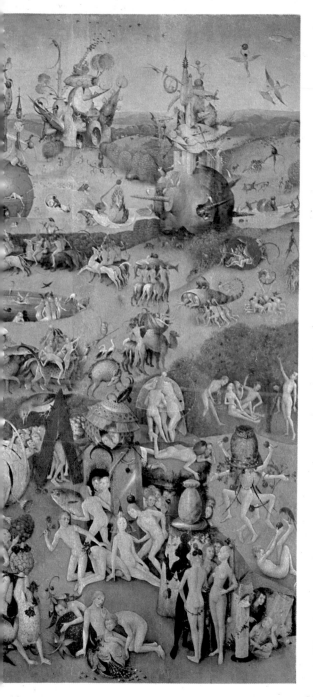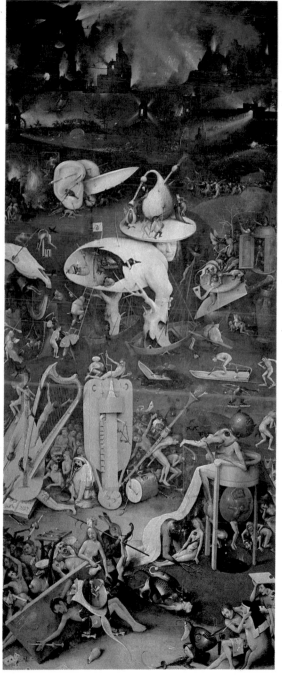

25–30 Bosch *The Garden of Delights* *Circa* 1500

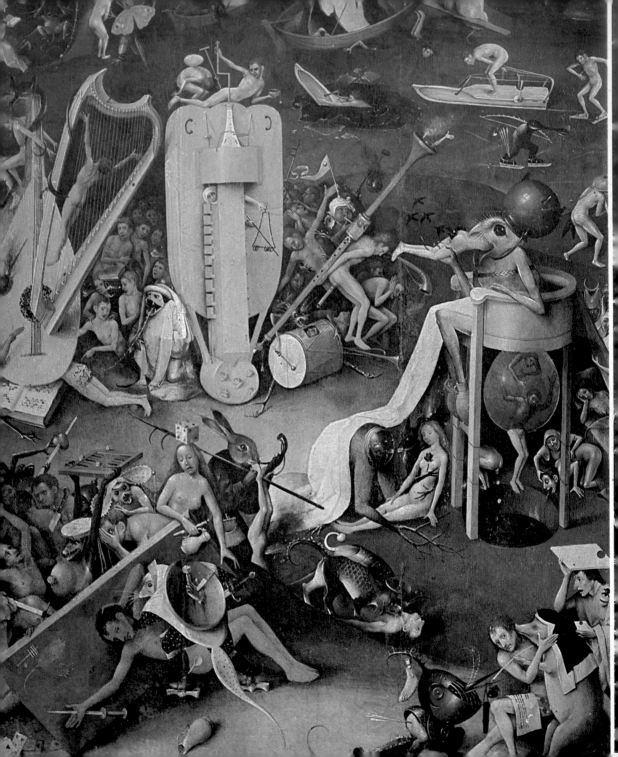

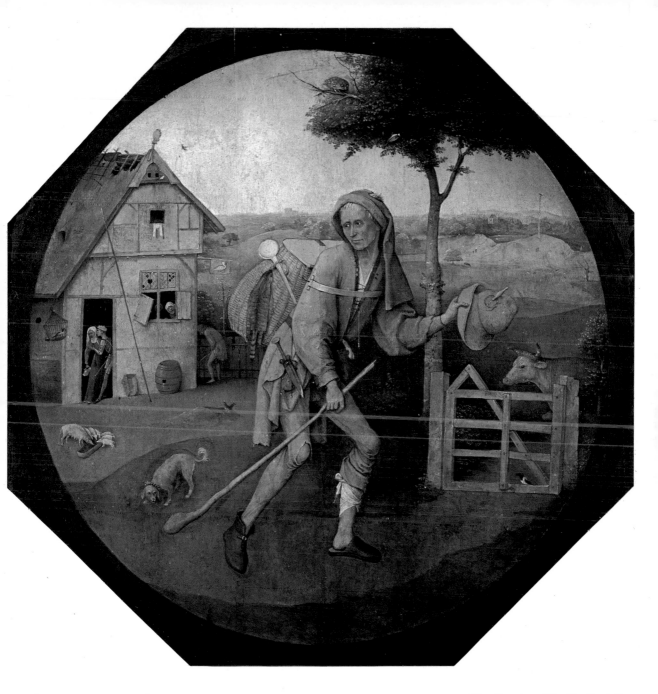

32　Bosch　*The Prodigal Son*

-31　Bosch　*The Last Judgment*　1504?

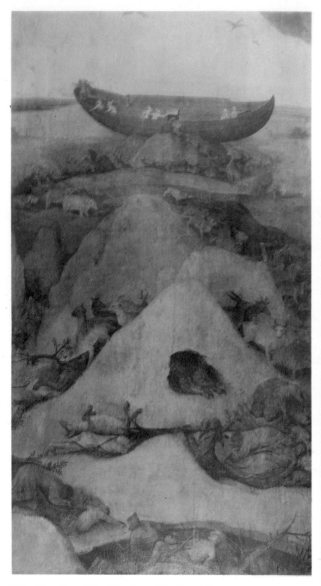

33 Bosch *The Flood: Noah's Ark*

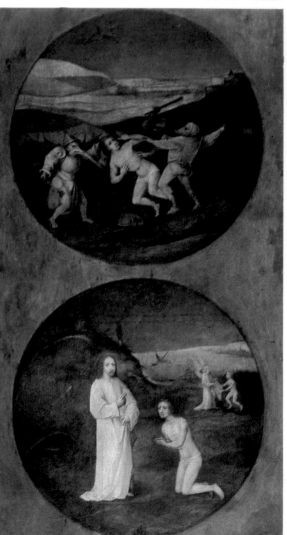

The Flood: Biblical Parables

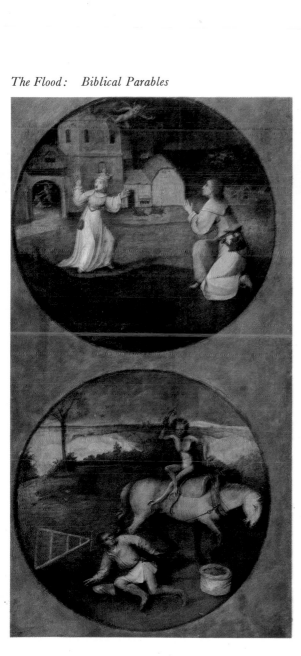

36 Bosch *The Flood: The World of Evil*

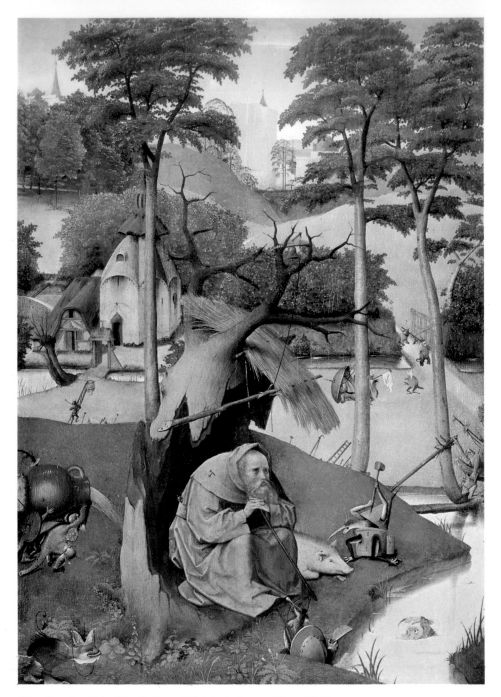

37 Bosch *The Temptation of Saint Anthony* *Circa* 1515

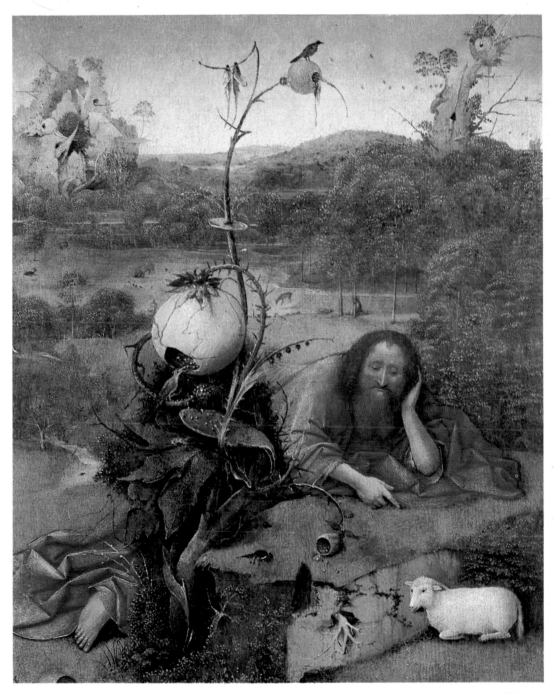

38 Bosch *Saint John the Baptist in the Wilderness*

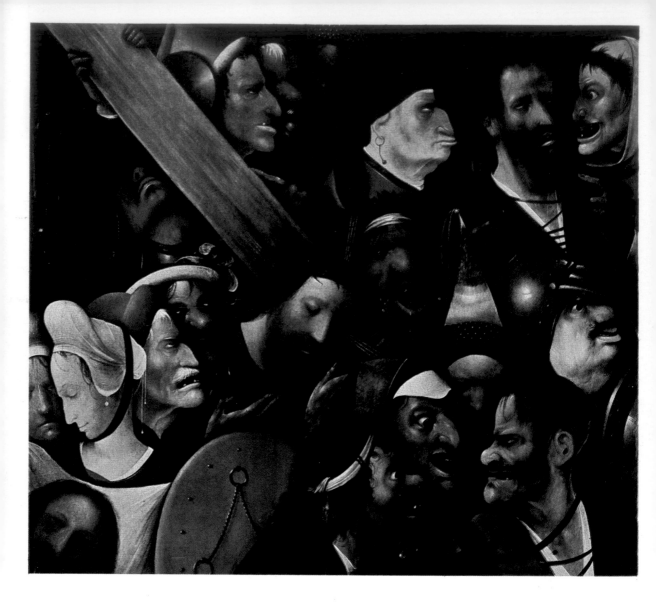

39–40 Bosch *The Bearing of the Cross* *Circa* 1505

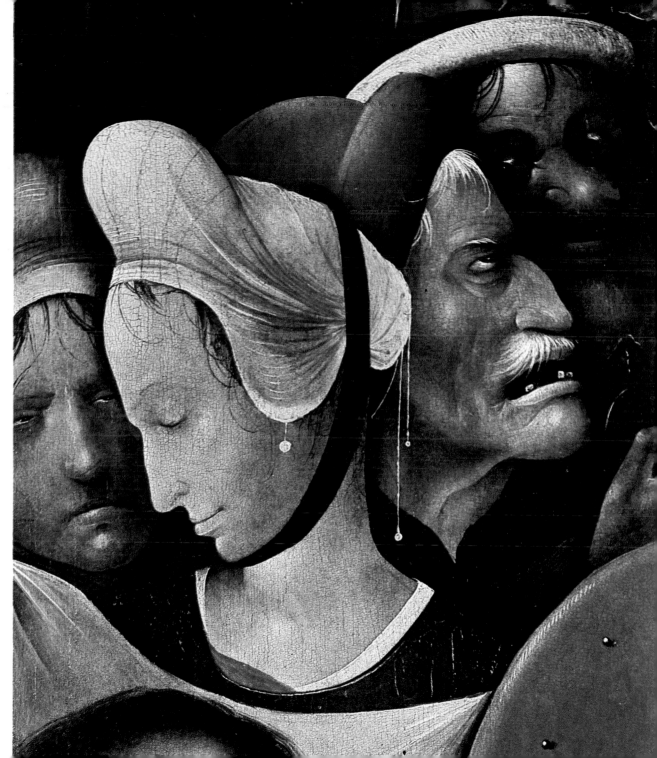

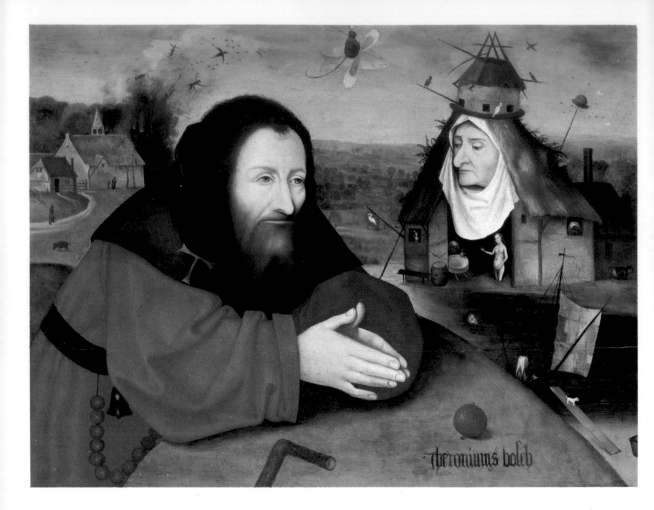

41　Bosch　*The Temptation of Saint Anthony*

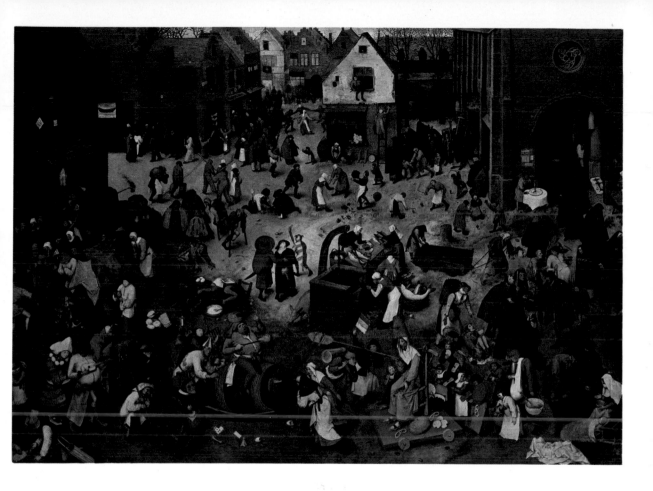

42–44 Bruegel *The Battle between Carnival and Lent* 1559

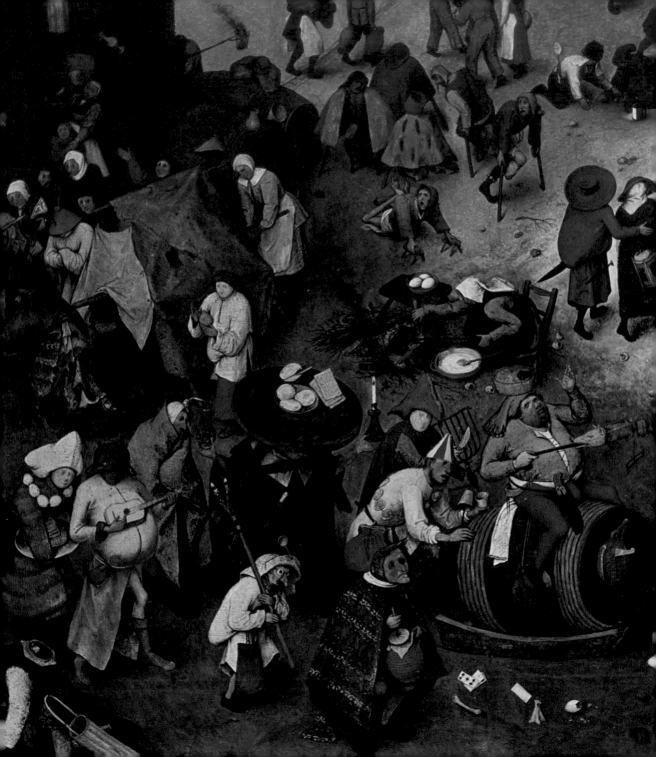

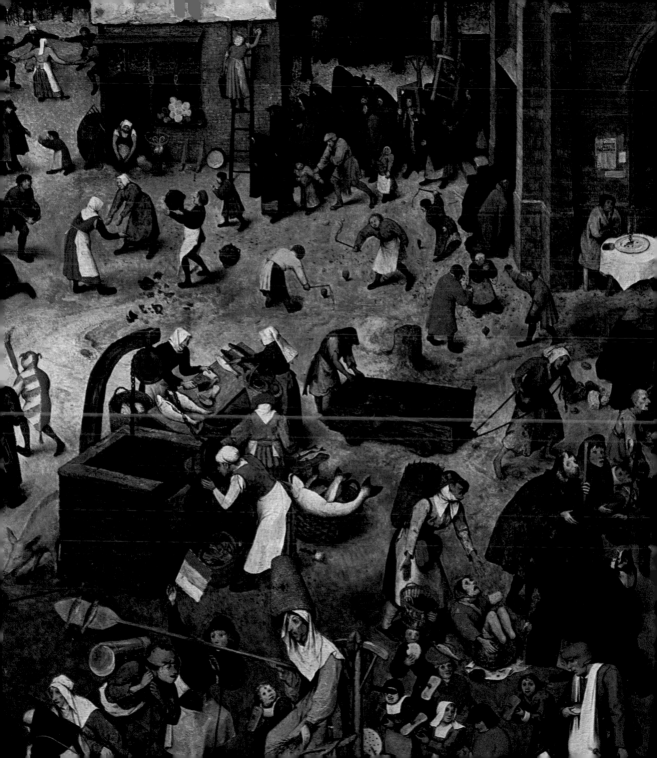

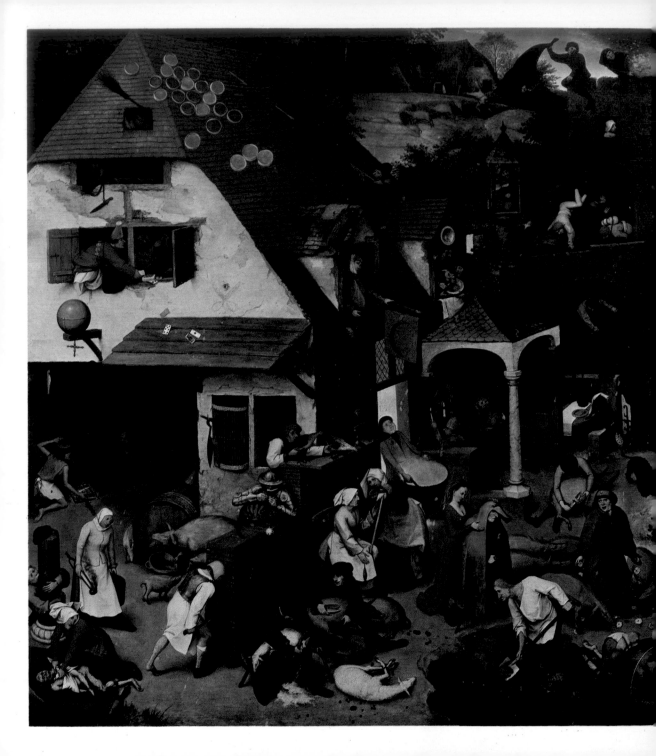

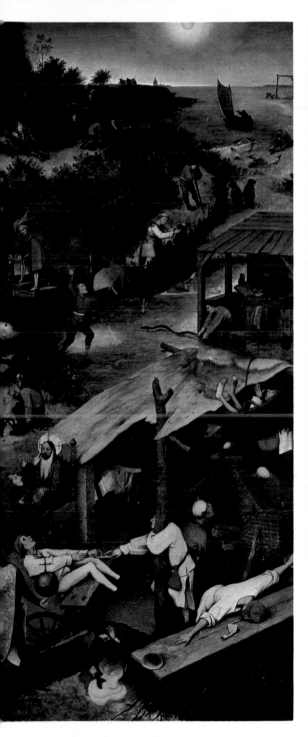

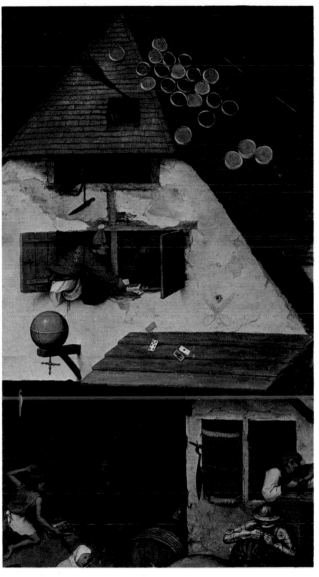

45–47 Bruegel *The Netherlandish Proverbs* 1559

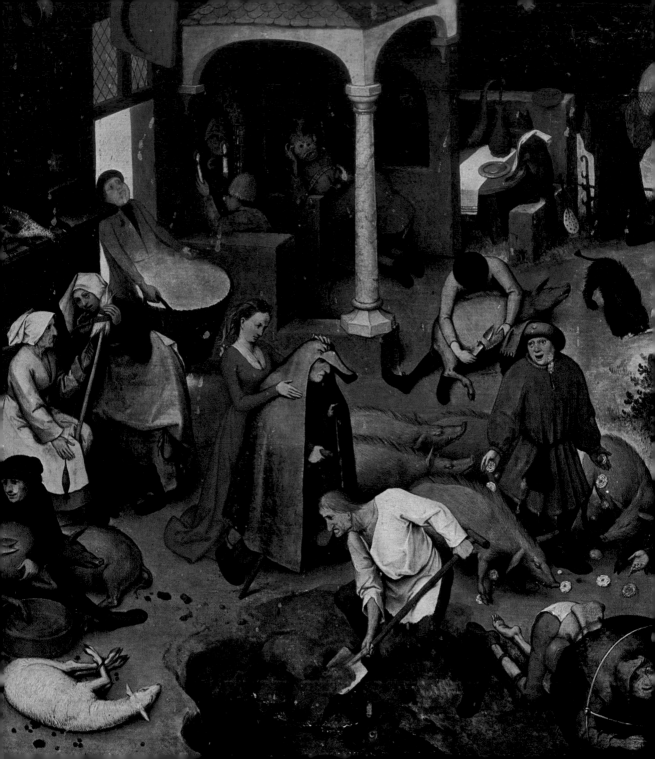

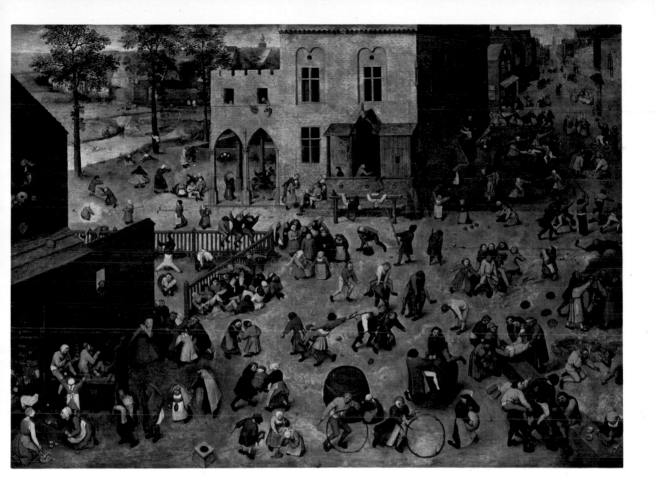

48–50 Bruegel *Children's Games* 1560

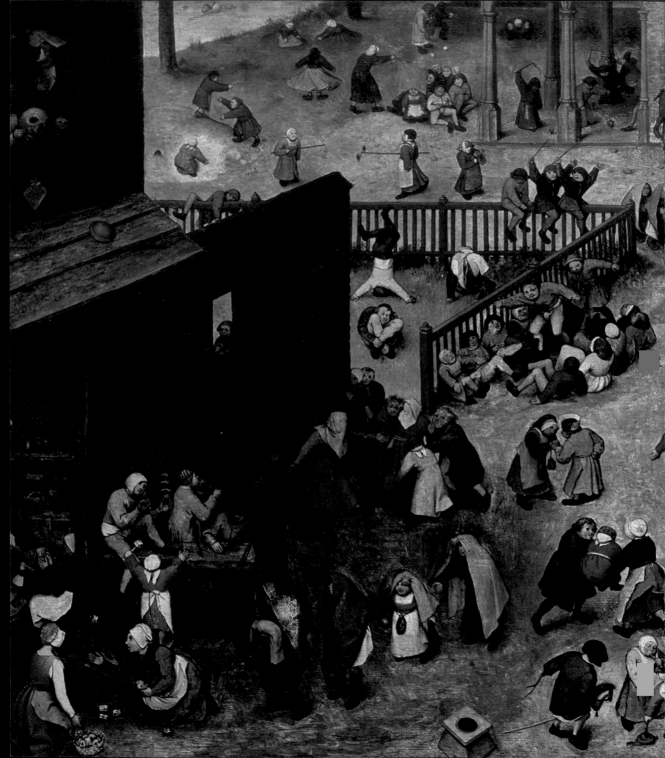

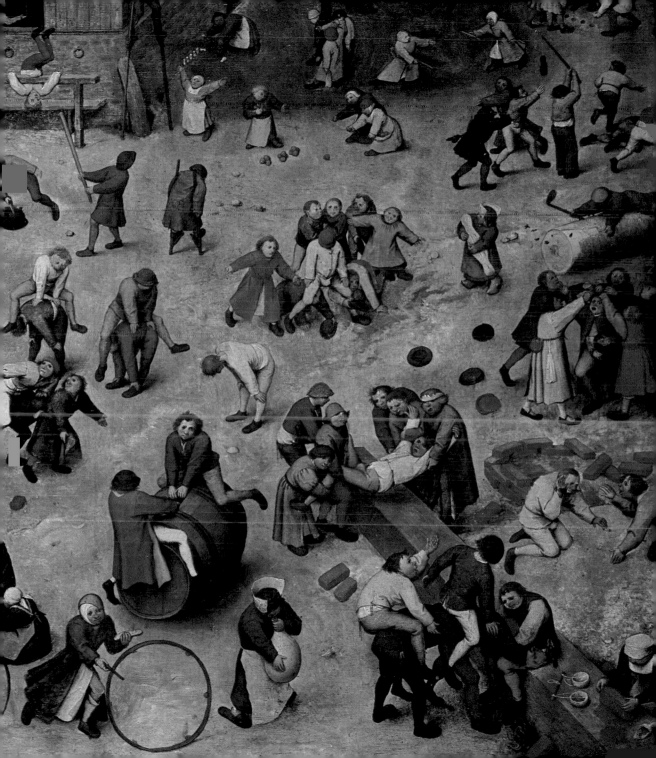

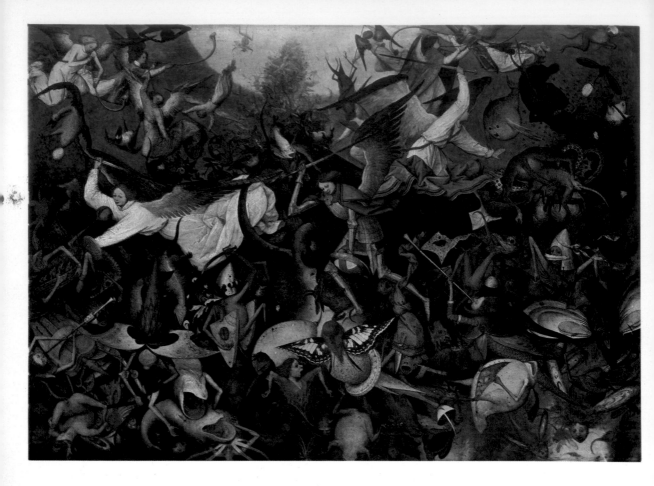

51–52 Bruegel *The Fall of the Rebel Angels*

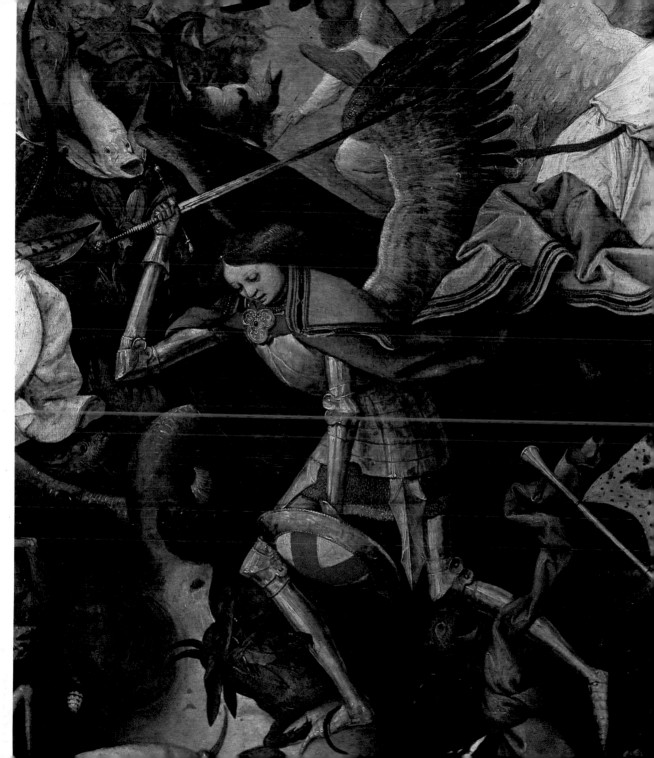

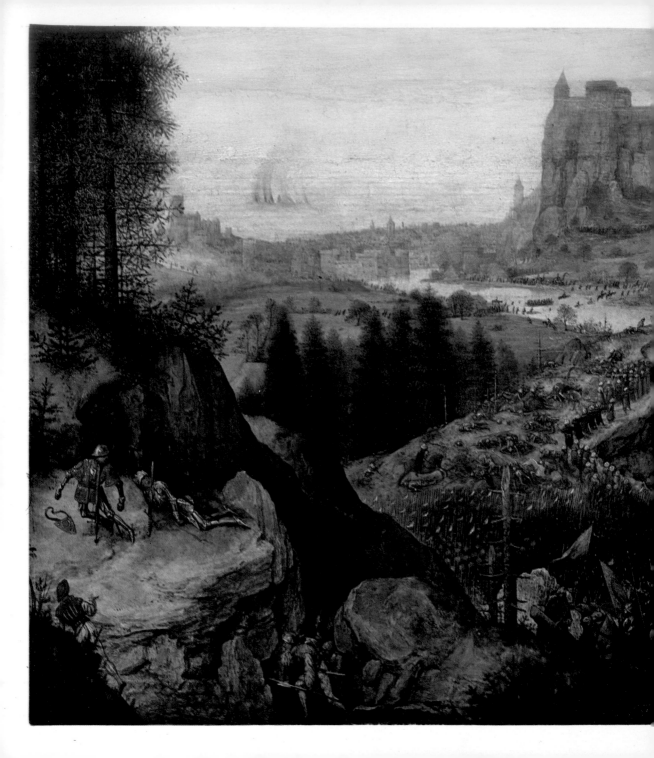

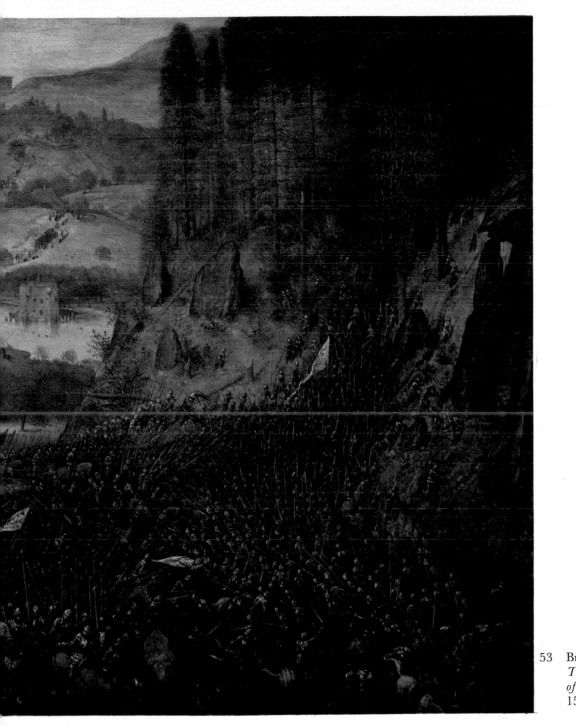

53 Bruegel
The Suicide
of Saul
1562

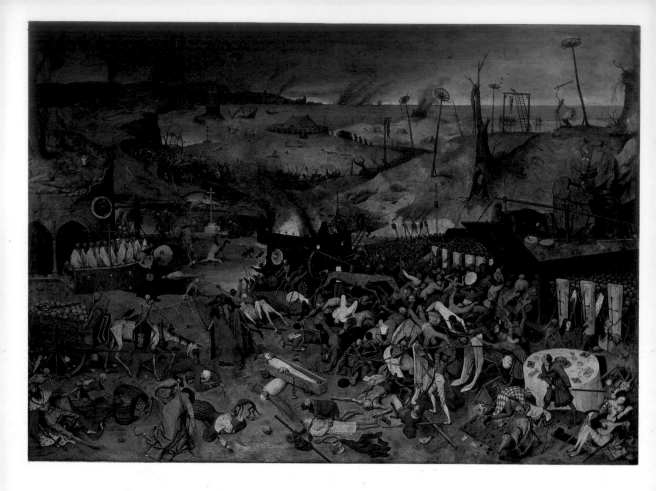

54–56 Bruegel *The Triumph of Death* 1562

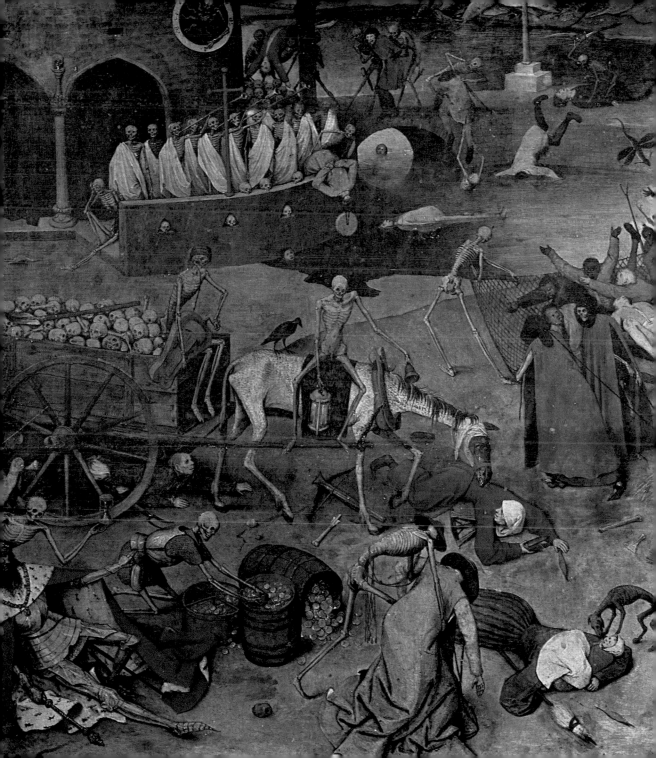

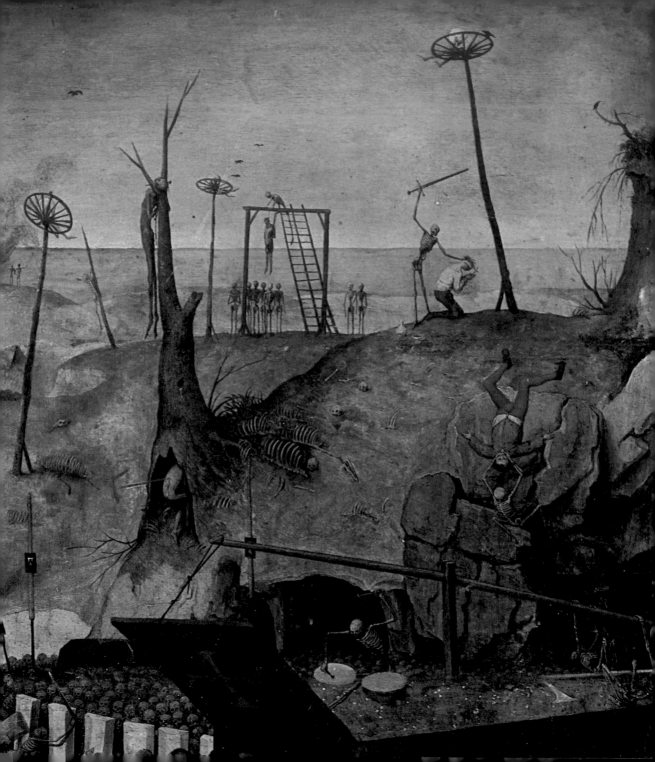

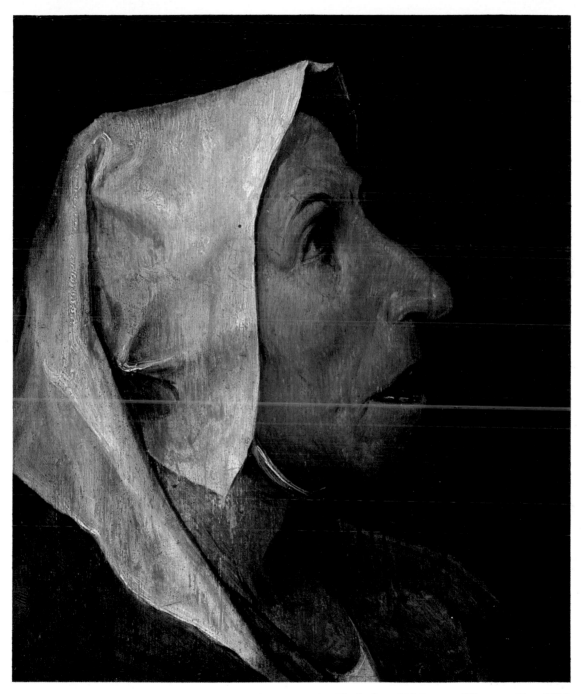

57 Bruegel *Head of an Old Peasant Woman* *Circa* 1568

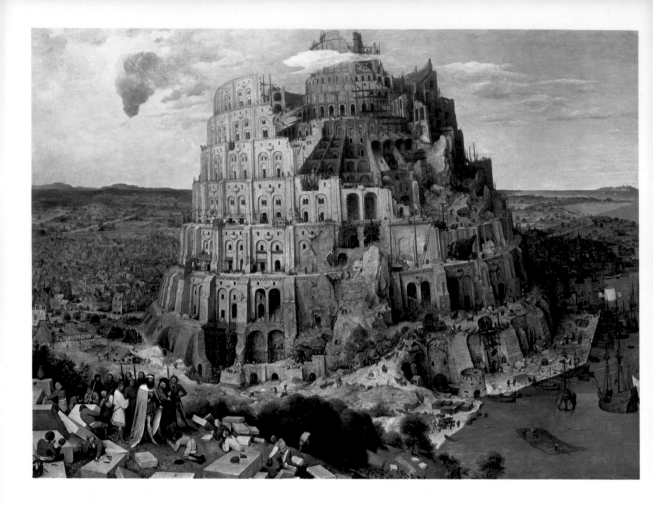

58–59 Bruegel *The Tower of Babel* 1563

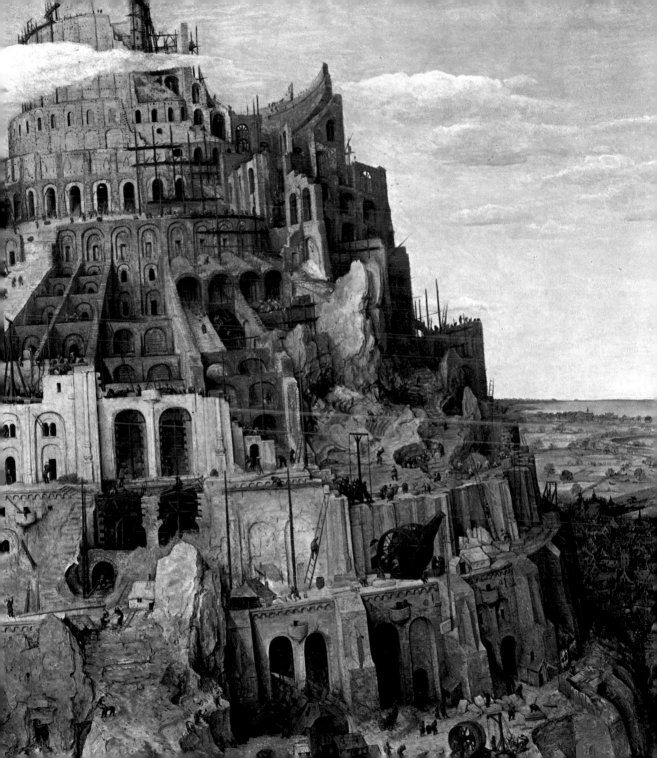

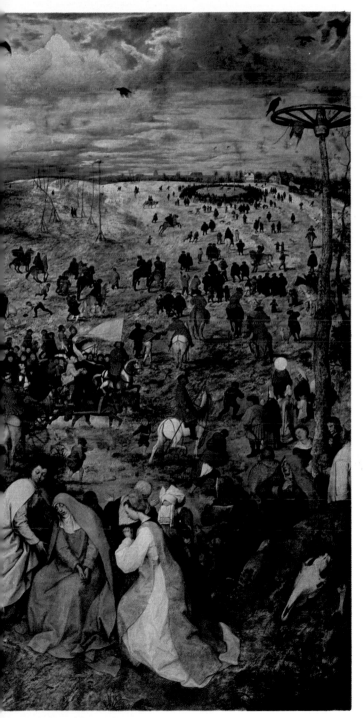

60　Bruegel　*The Carrying of the Cross*
1564

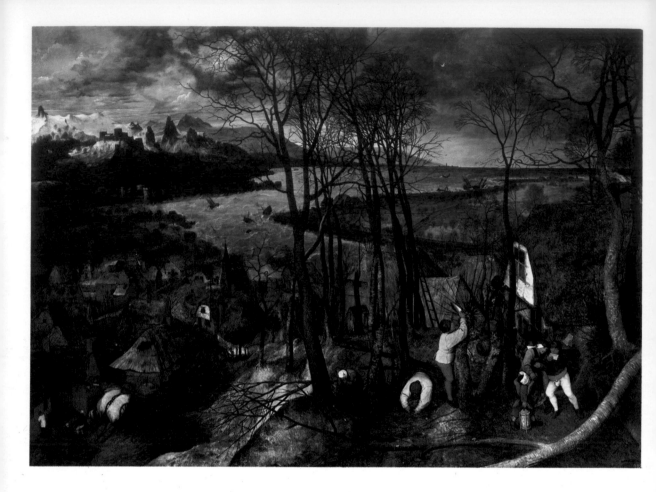

61 Bruegel *The Dark Day* 1565

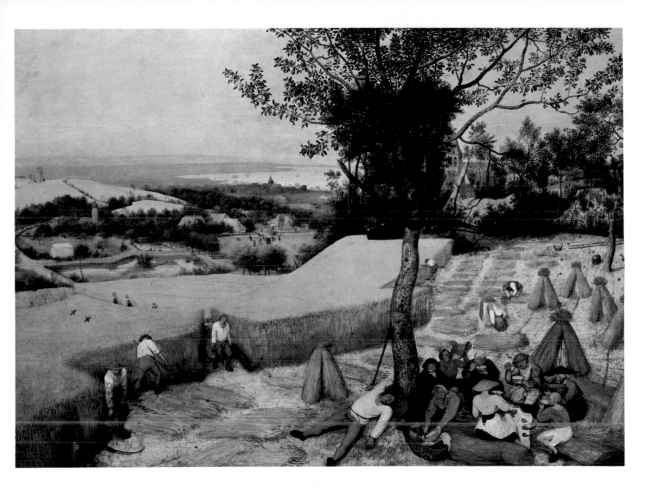

62 Bruegel *The Harvesters* 1565

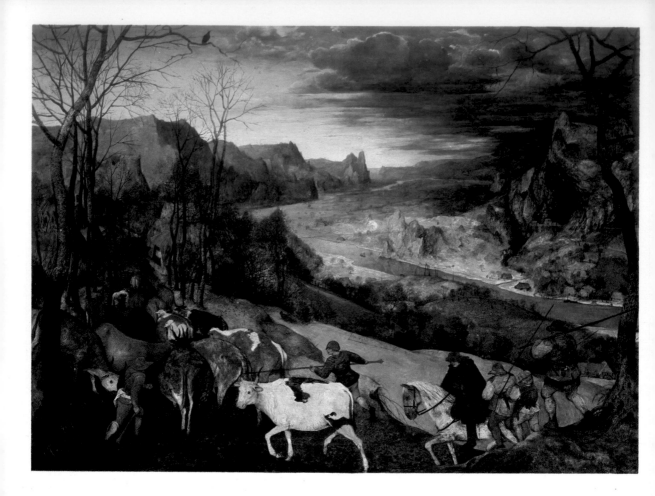

63 Bruegel *The Return of the Herd* 1565

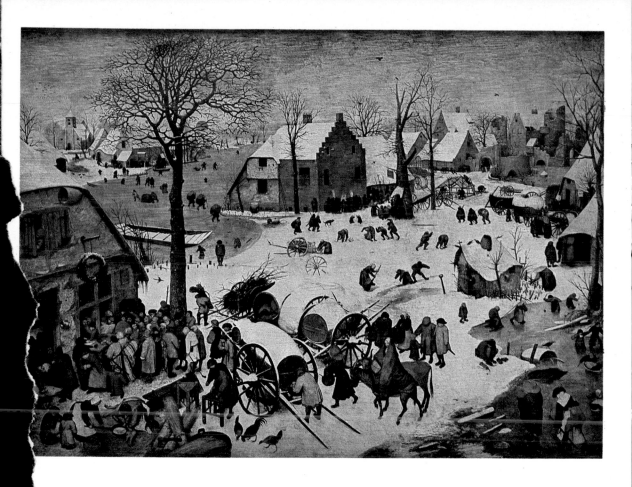

Bruegel *Numbering at Bethlehem* 1566

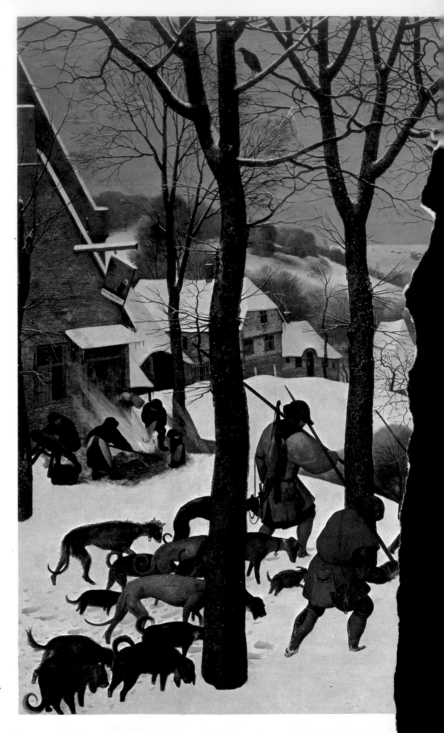

64 Bruegel *The Hunters
in the Snow* 1565

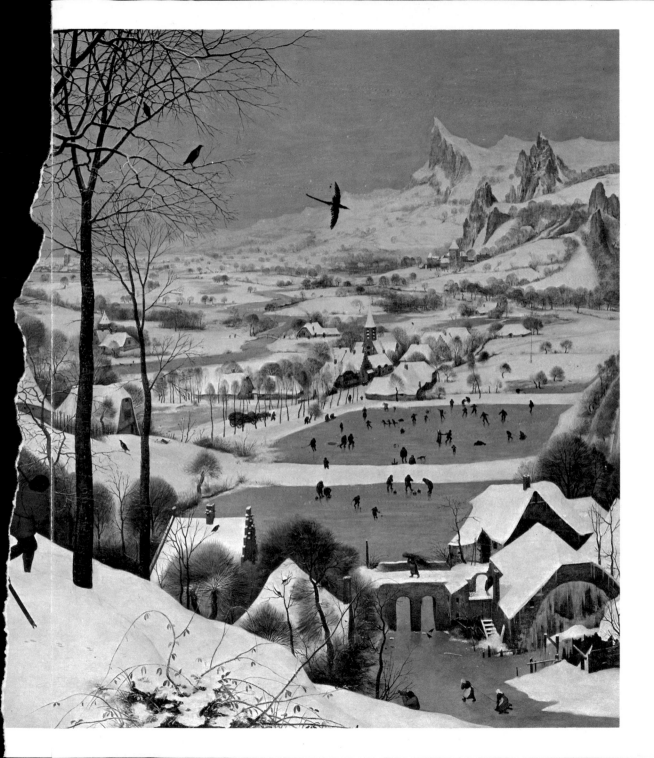

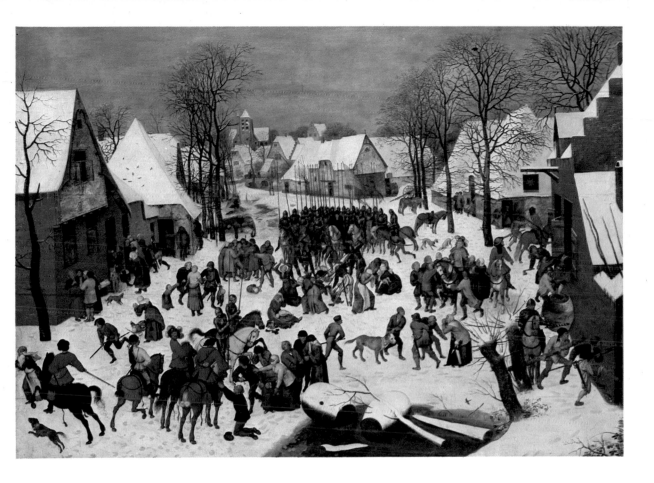

67 Bruegel *Massacre of the Innocents* 1566

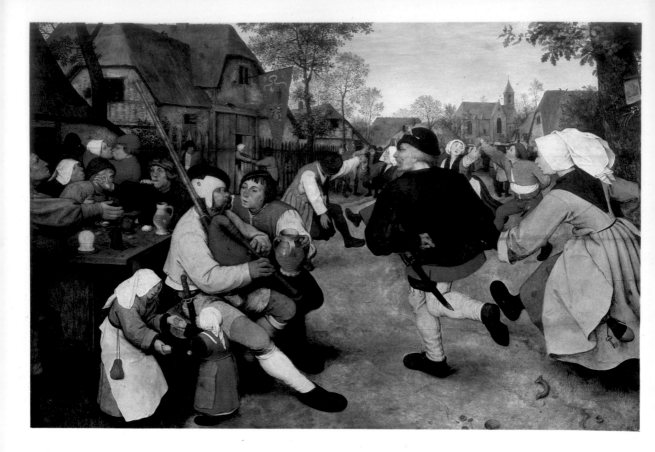

68–69 Bruegel *The Peasant Dance* *Circa* 1567

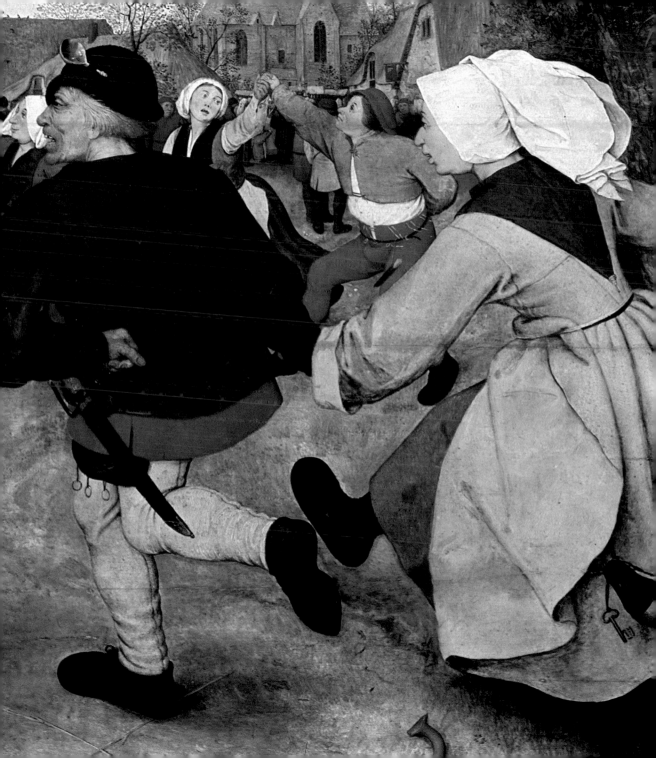

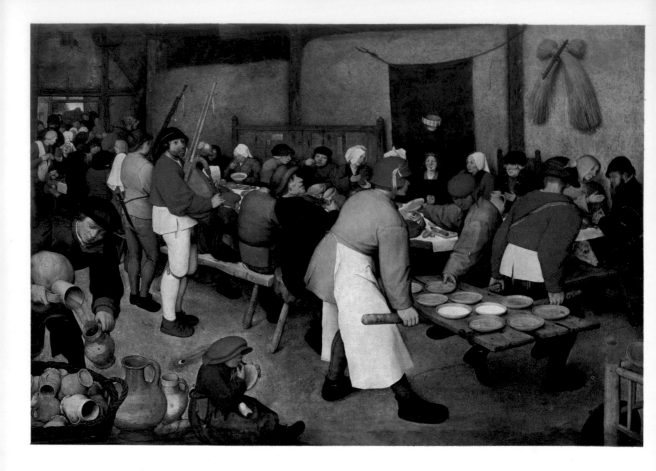

70 Bruegel *Peasant Wedding* 1568

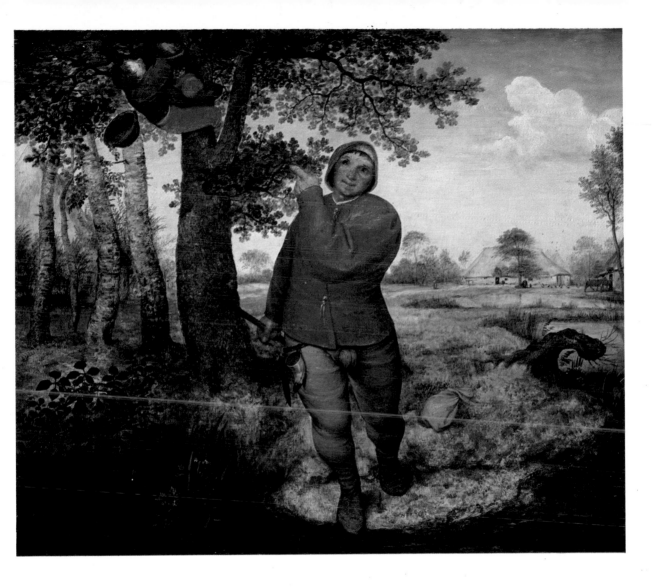

71　Bruegel　*The Peasant and the Birdnester*　1568

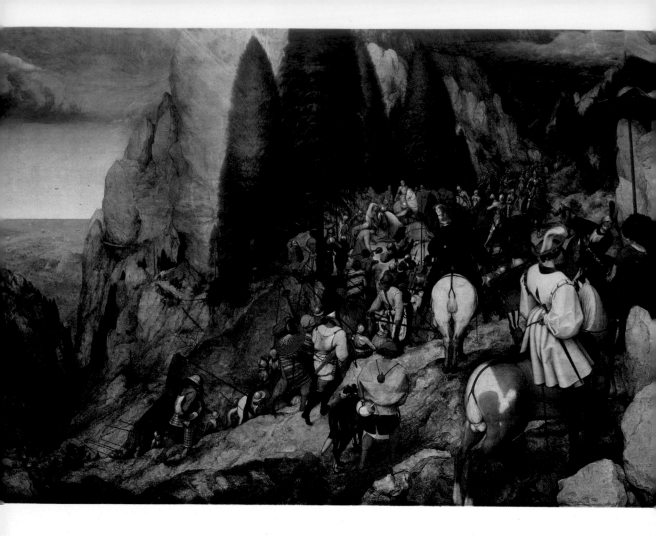

72 Bruegel *The Conversion of Saint Paul* 1567

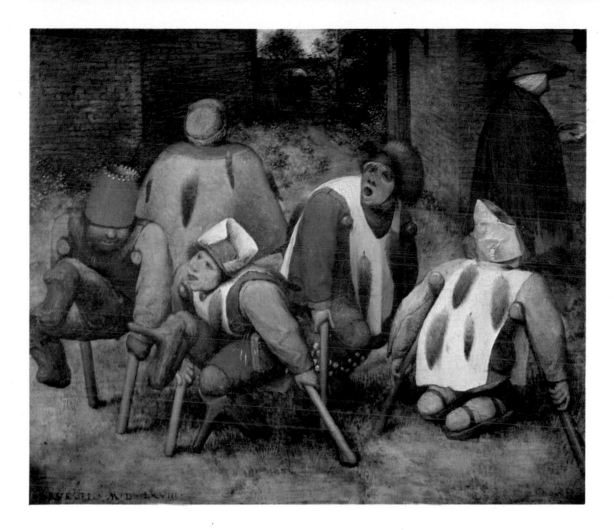

73 Bruegel *The Cripples* 1568

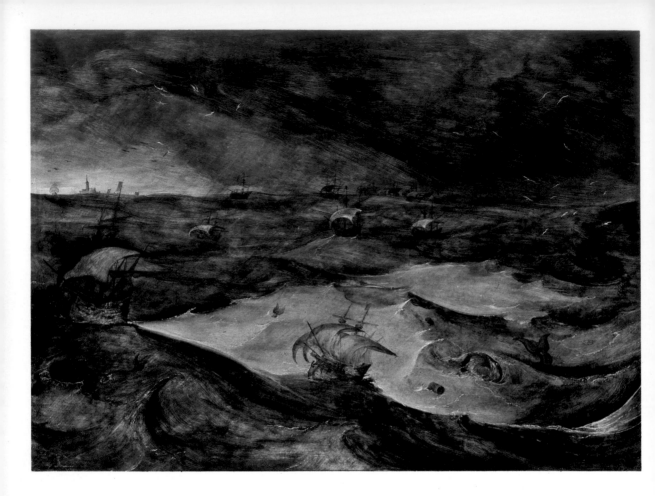

74 Bruegel *Storm at Sea*

Bosch/Bruegel

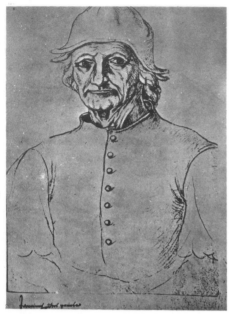

Bosch *Self-Portrait*

Bosch/Bruegel

Even if the knowledge that we have concerning the late medieval painters Bosch and Bruegel were plentiful, any study of their work would be thin indeed without reference to the historical setting within which they worked. As it is, the paucity of facts about them prescribes a refreshing plunge into the crossroads world of the Northern European Middle Ages becoming the Renaissance.

For pace, drama, and sheer grandeur, it was a time that equals any like period before or since. In a word, things were happening. Lively commerce nourished development of the arts; the printing press was invented, a "step for man" of staggering consequences; the Roman Catholic religion, heretofore the great unifying—and suppressive—instrument of kings and popes alike, was beginning to lose its hold on the mind and spirit of man.

It is possible to speak only in the most general terms about the direct consequences of such events. Rather, they are better considered as seeds planted close together and under the most fortuitous conditions for growth. For grow

82

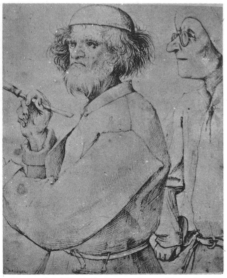

Bruegel *The Artist and a Connoisseur* 1560–61?

they did, and their plants intertwined with each other, lending mutual support and spreading farther with every season.

To trace the history of art, particularly in this period, is to trace history itself. In the late fourteenth century, John the Good, King of France, presented his son, Philip the Bold, with what is now known as Burgundy. That gift began a rapidly proliferating series of advances in art and commerce, advances that gave birth to virtually a century of tingling cultural climate that was the "kelson of creation" within which many artists flourished, among them Bosch and Bruegel. For Philip and several Dukes of Burgundy who succeeded him sought to enlarge their territory by acquiring the Netherlands. During the Hundred Years' War Burgundy grew to include eventually what is now Holland and Belgium, and, except for Lorraine, the land between Belgium and Dijon, then the Burgundian capital. Ultimately the court was moved to Brussels, a natural consequence of the fact that the dukes spent more time in the North than anywhere else.

The Northern cities of Antwerp, Ghent, and Brussels enjoyed lively trade with all of Europe and became wealthy

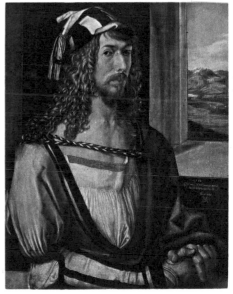

Albrecht Dürer *Self-Portrait*

centers of culture. Dukes built palaces and commissioned Northern artists to decorate them. Churches, books, tombs, and altarpieces were similarly in need of artistic beautifying, and the dukes did not hesitate to pay lavishly for the fulfillment of their aesthetic needs. Italian traders with business in the Netherlands often commissioned paintings. Italian and French artists were attracted by the cultural activity, and they too visited.

Ducal artistic preference was especially for small, finely worked creations: seals, clasps, boxes for sacred relics, and the delicately colored illustrations for the Books of Hours. This Burgundian-induced taste for the decorative blended with the natural Flemish penchant for realistic detail to produce rather small paintings, finely drawn and colored, with virtually no reference to landscape. When Italian painting preferences took hold in the North, the original blend took on the Southern spaciousness of landscape, soft rendering of figures, and liking for a comparatively large canvas. The result was the so-called International style, stunning examples of which can be seen in the works of Flemish artists like Jan van Eyck and Roger van der Weyden.

In 1477 (Bosch was a young man, Bruegel not yet born), Charles the Bold, Duke of Burgundy, died, and the Bur-

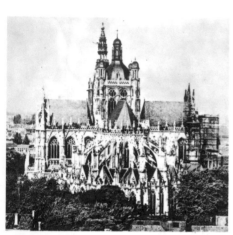

Cathedral at 's Hertogenbosch, the Netherlands

gundian era ended. The French king saw his chance and surrounded the Dijon area; Burgundy was split, the Northern territories becoming part of the Habsburg domain. By 1500 King Charles I, great-grandson of Charles the Bold, inherited much of Spain and Italy, and all of the Netherlands. After he was elected Holy Roman Emperor in 1519, the serious, benevolent Charles began a long devotion to the idea of holding the crumbling empire together in the face of newly nationalistic kings and the controversy over corruption in the Roman Catholic Church. His efforts to check Martin Luther's Protestant rebellion—a movement well served by the continual developments in printing—ultimately failed. But in the course of those years of trial, from 1519 until his abdication in 1555, his gentle strength and moral conviction won him the loyalty of many Netherlandish nobles.

Things changed drastically when Charles died, leaving Spain and the Netherlands to his son, Philip. Spanish-born, Philip was radically different from his father. Where Charles was both brilliant and generous of spirit, Philip was rigid and meticulous. Charles lived and ruled in the Netherlands, where he was born; Philip ruled from Madrid. The Netherlands kingdom was as far away from his understanding and sympathy as it was from Spain itself. Philip's deliberate, cruel oppression of Protestantism resulted

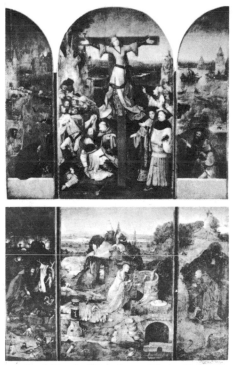

(top) Bosch Altarpiece of Saint Julia
Bosch Altarpiece of the Hermits

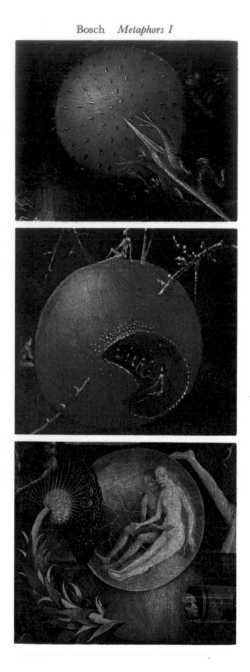

finally in the Eighty Years' War, which began in 1567. Bosch had been dead for fifty-one years; Bruegel was to die just two years later.

The facts of Hieronymus Bosch's life are as few in number as the interpretations of his work are many. He was born in 's Hertogenbosch, probably in 1450. As a member of the Brotherhood of the Holy Virgin, he designed stained-glass windows and a crucifix for the Brotherhood chapel in Saint John's Cathedral. About 1480, he married. In 1504, he received a commission to paint *The Last Judgment*. When he died, in 1516, the Brotherhood honored him with a grand funeral.

Such a paucity of information about an artist's life nearly always engenders an aura of mystery, which in turn tempts scholars to ever-greater feats of interpretative reading of his work. The case of Bosch is no exception. *The Garden of Delights*, for instance, is most often seen as a subtle indictment of sin, for in the fifteenth and sixteenth centuries sin and its avoidance were every Netherlander's constant concern. But another interpretation has been offered by Wilhelm Fraenger (*Millennium of Hieronymus Bosch*, University of Chicago Press, 1952). It is based on the assump-

86

tion that Bosch was a member of the heretical Adamites, a sect dedicated to the belief that sexual intercourse was the only means of attaining a perfect union of nature with spirit, without which man could not receive the Holy Ghost. Seen within this context, *The Garden* becomes a glorification of lovemaking rather than an indictment of sin.

Basically, Bosch was a painter of religious subjects who displayed distinct leanings toward satire and dour comment, as well as the eternal Flemish interest in quotidian life. Bosch consistently reinterpreted religious iconography according to the contemporary Flemish concepts. His genius for fantasy led him into a realm of artistic expression that found its counterpart only in the surrealistic period of the twentieth century. In considering this penchant for allusive, symbolic creations, it is important to remember that his so-called fantasy paintings did not in fact mystify his contemporaries. Seen from the vast distance of some four and a half centuries they are indeed puzzles, an unavoidable result of the fact that the medieval vocabulary, so rich in signs and symbols, was virtually lost to subsequent ages. Efforts to dispel the shadows thus cast on Bosch's work have ranged from feats of both prodigious scholarship and imagination to the application of dream analysis.

Cover, Sebastian Brant's *The Ship of Fools*

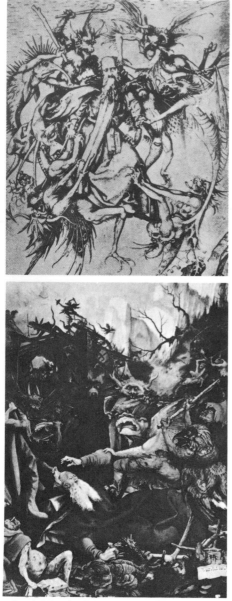

(top) Martin Schongauer *The Temptation of Saint Anthony* (detail)
Grünewald *The Temptation of Saint Anthony* (detail) 1515

It is not difficult to understand why symbolically patterned pictures were so much a part of the world of the fifteenth and early sixteenth centuries when one remembers that Gutenberg did not begin his printing experiments until 1440. Pictures communicated ideas through symbols with which everyone was familiar. The concept of heresy, for instance, was consistently represented by an owl, sex by fruit, lust or rage by a horse, life by an egg.

How much an artist can say to the ages that succeed his own is a measure of his genius. In spite of an information gap that places his work in a necessarily esoteric context, Bosch's paintings will speak forever. They go beyond being some of the most profound expressions of the medieval world view and into the timeless realm of the human unconscious.

Pieter Bruegel was born in Brabant about 1525, almost ten years after Bosch's death. Again scarcity of fact must be supplemented through reference to the work that remains.

For some years Bruegel made his home in the thriving commercial and cultural center of Antwerp. Just after 1551,

88

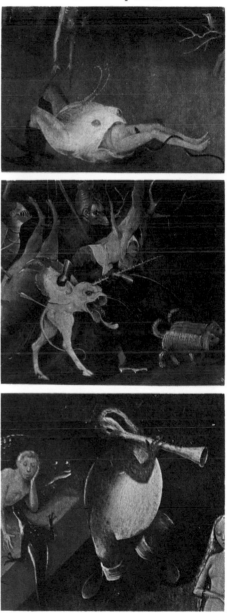

he journeyed to Italy, probably getting as far south as Sicily. In 1563, he married the daughter of P. Coecke van Aelst and moved to Brussels.

Throughout his life, Bruegel remained relatively independent of the Italian developments in painting style that were popular with other Flemish painters. His world was landscape, in all moods and weathers, which he rendered with a palette of chiefly blues, greens, and rich browns. But that world was not without people; perhaps the most outstanding fact about Bruegel's work is that it unsentimentally records his unremitting interest in peasants and their doings. Many of the earlier paintings are heavily populated bird's-eye views of various seasonal activities. The late paintings, however, show a marked change: the artist's point of view has moved in for a closer, eye-level look. Bruegel apparently became as interested in examining the faces of his characters as he was in recording their activities. In *The Carrying of the Cross* or *Peasant Wedding*, for instance, the viewer has a sense of having stepped into a world created specifically for instruction on the different types and degrees of human emotion.

Bruegel's seasons' paintings are perfect blends of the real world of daily events and the world of cosmic landscape

Bosch *The Garden of Delights* (with panels closed) *Circa* 1500

in which the "action" scene is hung. The landscape is distant and imagined, cosmic beauty juxtaposed with the rudeness of the actual world. Bruegel is rightly remembered as the first of the great landscape masters, for he succeeded in expressing the eternal connection between dream and waking, between the ideal and the real, the majesty of nature and the commonality of man.

Bruegel was not the most popular painter of his day, a not too surprising fact when one remembers that the Southern Renaissance, that is the Italian, was in its finest—and most influential—hour. He worked against the widespread practice of imitating the Italian painters.

The most accomplished, and famous, of these imitators was Frans Floris (1517–1570), who studied painting in Rome and later opened a school in his native Antwerp. So fine were his ambitious figure compositions—and so reminiscent of the titan of the South, Michelangelo—that he enjoyed the patronage of William of Orange and of many Flemish and Spanish notables. By comparison, Bruegel's work must have suffered. His acutely perceived scenes of daily life were perhaps a little too familiar to his countrymen, and, next to the spacious grace of the Italian paintings, even a bit primitive.

But the best an imitator can do is convey someone else's discovery in the realm of truth. Thus it is that the work of Frans Floris is now important only insofar as it is a reflection of another's genius, evidence of the power of the truly unique mind to capture and control other, lesser imaginations. Owing to the refinements of vision that only time can bring, Bruegel's work is today considered as formidable, authentic testimony to the separate genius of the Northern Renaissance.

Dominicus Lampsonius *Portrait of Bruegel* 1572

Lucas Cranach *Portrait of Martin Luther*
(detail) 1529

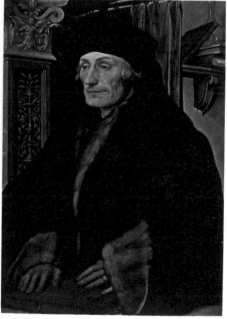

Hans Holbein *Portrait of Erasmus* 1522

NOTES ON COLOR PLATES

Note. Any dating or strictly ordered arrangement of Bosch's paintings is virtually impossible, for much of the original work has been lost. Many copies were made—some complete with forged signature—in his lifetime.

Hieronymus Bosch (Circa *1450–1516*)

1. *The Cure of Folly*

1475–1480 Oil on wood 47.9 × 34.9 cm Museo del Prado, Madrid

This *tondo* (a circular painting or sculptured medallion) marks a major innovation in painting—the vast, receding landscape, a panoramic setting without figures that creates a spatial context for the foreground scene. The inscription appearing at the top and bottom of the painting was well known in Netherlandish literature and imagery of the day. Lubbert Das (the Flemish literary name for a simpleton) requests the "master" to cut out the stone of folly. The plump old Lubbert will probably be made even madder, for the doctor is wearing a funnel cap, the medieval symbol of deception.

2. *The Seven Deadly Sins*

1475–1480 Oil on wood 113.7 × 147.4 cm Museo del Prado, Madrid

Bosch painted this early work on a tabletop in the village of Oirschot, to which he moved with his newly acquired wife. The four *tondos* represent the final experiences of the soul: *Death, The Last Judgment, Paradise,* and *Hell.* The brighter central *tondo* has a fringed eye of God and bears the warning, "Beware, for God sees all." "All" includes man's evil infractions, which are depicted in the seven allegorical scenes surrounding the eye: Vanity, Anger, Lust, Sloth, Gluttony, Covetousness, and Envy. With this painted sequence of quotidian events that conveys a realistic social and a moral message, Bosch brought to painting another new mode. Seen here and in Plate No. 1 is the recurring suggestion of a terrestrial ball, a metaphysical image that haunts much of Bosch's work.

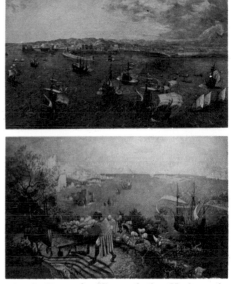

(top) Bruegel *View of the Harbor of Naples* 1562–63?
Bruegel *Landscape with the Fall of Icarus Circa* 1558

3. *The Conjuror*

1475–1480 Oil on wood 54 × 66 cm Musée Municipal, Saint-Germain-en-Laye

Some scholars consider this work to be a copy, but most place it among the originals. It belongs in the same thematic context as *The Cure of Folly* and *The Seven Deadly Sins:* an indictment of human folly. The spectators are all plump

93

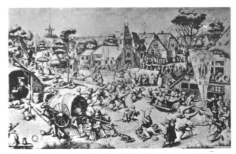

Hieronymous Cock *The Kermesse of Saint George*

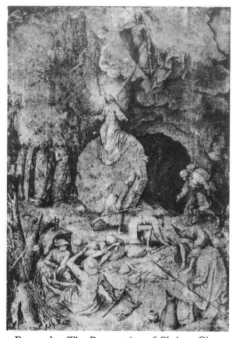

Bruegel *The Resurrection of Christ* *Circa* 1562

victims of the medieval con man. (Small but definite confirmation of this is the frog, symbol of credulity, that has plopped onto the table.) The ball in the conjuror's fingers is about to disappear, as is the stupefied simpleton's purse. The child is delightedly watching the activities, conforming to the Flemish proverb: "He who lets himself be fooled by conjuring tricks loses his money and becomes the laughingstock of children." The owl, seen peeping out of the basket attached to the conjuror's belt, symbolizes heresy, the ultimate danger of witless credulity. The white ring resting against the table is the cosmic-referent symbol popular in works of the period.

4. *Ecce Homo*

Oil on wood 75 × 61 cm Staedel Institute, Frankfurt

In this work the rather theatrical setting created by the realistic background in contrast with the stagy look of the foreground building and platform suggests that the artist might have been inspired by the annual religious procession in Bois-le-Duc ('s Hertogenbosch). The speculation that this is one of the artist's earliest Passion paintings is reinforced by the use of two rather unsophisticated "story" instruments: inscriptions, and miming gestures for the crowd figures, who are thus presented as involved not so much in real-life vulgarity as in simply acting out their parts.

5. *The Marriage at Cana*

Oil on wood 93.4 × 73.9 cm Boymans-Van Beuningen Museum, Rotterdam

At once elegant and bizarre, sacred and profane, the elements in this painting are clearly meant to show the eternal difference between aspiration and fact, ideal and real. Only the bride and groom, Christ, Mary, and the host are quietly attentive to the miracle of the changing of the water to wine; the other guests are busy gossiping. In the background a priest of Satan waves his wand as he stands by an altar on which are mysterious vials and other objects suggestive of the Black Arts. The brilliant arrangement of figures and the contrast in activities conveys the message: the serene and superior spiritual world is always a threat to and threatened by the world of evil.

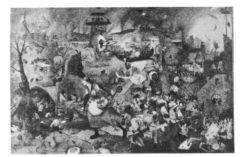

Bruegel *Dulle Griet (Mad Meg)* 1562

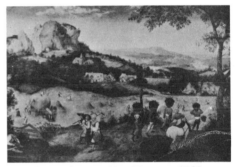

Bruegel *The Hay Harvest* 1565

6. *The Adoration of the Magi*

Oil on wood triptych 131.1 × 72.1 cm (central panel) 131.1 × 33.0 cm (side panels) Museo del Prado, Madrid

The central panel of this superb picture-poem depicts the narrative theme of the visit of the three wise men twelve days after the Nativity in such a way as to suggest the celebration of a Mass. Mary is the altar; Balthazar, kneeling center, is the celebrant, Melchior and Gaspar the acolytes. Saint Joseph, left panel, and Saint Agnes, right panel, are the donors. As

Bosch *Study of*
Ship of Fools

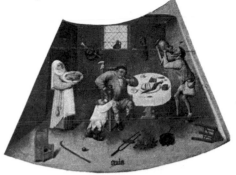

in *The Marriage at Cana*, the sacred and profane worlds are represented—co-existing but not co-inhabitable. Thus the three worshiping wise men are seeking the serenity of the spiritual world; but the shepherds, representing the evil world, are mere observers. Except for small areas of worldly activity, the great expanse of background is dominated by light and peace.

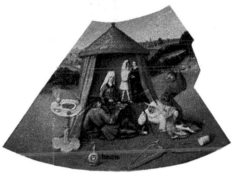

7. *Christ Carrying the Cross*

Oil on wood 57 × 32 cm Kunsthistorisches Museum, Vienna

On the reverse side of this painting is a *tondo* of a child playing called *The Allegory of Innocence*. The two sides are thought to depict the beginning and end of Christ's life.

8. *The Adoration of the Shepherds*

Wallraf-Richartz-Museum, Cologne

There is division among scholars as to the authenticity of this work. Somewhat unlike Bosch's usual treatment are the faces and heads; on the other hand, the perverse expression of the peering spectator achieves a contrast that is typically Bosch.

97

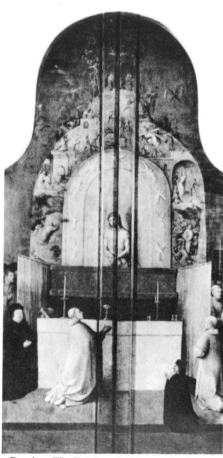

9. *The Crowning with Thorns*

Tempera and oil on wood 73.1 × 59.1 cm National Gallery, London

To this Passion painting Bosch has brought a sense of timeliness and urgency with respect to the moral lassitude and disorder in his own day. The blunted arrow in the cap of the tormentor who is about to place the crown on Christ's head signifies that the punishment for his act will be eternal damnation. The almost lip-licking anticipation of the professional torturer in the spiked collar and of the old man with the crescent of Islam on his shawl is particularly indicative of the depths of moral degeneration to which the artist feels people have fallen. Such mindless human cruelty is at the core of much of Bosch's thematic material.

10. *Saint Christopher*

Oil on wood 111.8 × 73.9 cm Boymans-Van Beuningen Museum, Rotterdam

The man in the dead tree, the monk and dog by the lake, the hunter hanging his bear are all inhabitants of the mundane world. They are without the supreme sense of spiritual purpose and direction that characterizes the central, larger-than-life figures of the saint and the Christ child. Note the delicate completeness of the receding landscape, almost a whole painting in itself.

98

Bosch *The Epiphany* (with panels closed)
Circa 1500

11. *Saint John the Evangelist in Patmos*

Oil on wood 62 × 41 cm Gemäldegalerie, Berlin-Dahlem

The serene sense of space, an effect of the receding, cool-toned landscape, blends with the shining, transcendental mood of Saint John. The spiritual-referent figures of the angel and the Virgin have their counterpart in the evil, satanic monster figure. As if to preserve the saint's mood of spiritual communion, the eagle of Saint John (lower left corner) is defying the monster, a clue to the fact that John has been interrupted while writing the Apocalypse, another such clue is the woodpecker routing insects, high in the tree at right (symbol of Christ combating the satanic hosts).

12–14. *The Haywain*

1480–1485 Oil on wood 141 × 100 cm (central panel) 141 × 66 cm (side panels) Museo del Prado, Madrid

The earliest of Bosch's triptychs, this presentation of the world in microcosm is an inventory of evil—its origin in Paradise (left panel), the worldly network of man's evil excursions (central panel), and finally the punishment of evil in Hell (right panel). In Netherlandish folklore, the hay wagon is a symbol of vanity. Thus in the central panel, multifarious groups of humanity are pictured in their pursuit of vain dreams. The hideous monsters pulling the wagon represent the worldly price that evil exacts, for they are agents of Satan

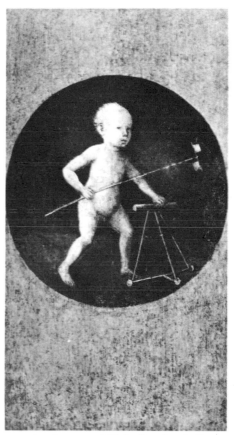

Bosch Reverse of *Christ Carrying the Cross*

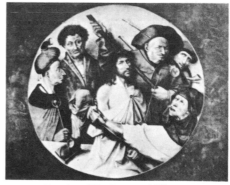

Bosch *The Crown of Thorns*

already engaged in drawing the greedy crowds toward their ultimate punishment. A restless sense of conflict between dream and reality seems to haunt this encyclopaedic painting—an indication both of the searching mental activity of the artist and the haunted, unsettled spirit of his age. Bosch had not yet reached the supreme control necessary to express his fantastical indictments of the human predicament—as in, for instance, *The Garden of Delights*. Nevertheless, the signs are unmistakable here: the economy with which he executes the sweep and force of the huge drama; the rich diversity of color; the cinematic sense of progressive scenes of action.

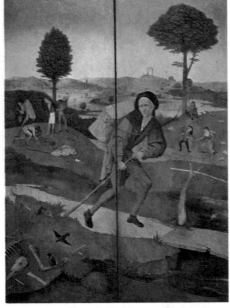

Bosch *Haywain* (with panels closed)

15–19. *The Temptation of Saint Anthony*

Circa 1500 130.0 × 116.6 cm (central panel) 130 × 53 cm (side panels) National Museum, Lisbon

Saint Anthony, in the midst of desert meditations after having renounced his family's wealth, was beset by a swarm of hissing, snarling fiends, demons and animals, all determined to supplant his faith with evil and obscene thoughts. Giants, soldiers and beautiful women were at their command, ready to force or cajole the saint away from God. In this fabulous triptych re-creation of that saintly trial, Bosch composed a symbolic scheme of references to the superstitious practices of the day. But so interlaced are the elements of his scheme that many details remain even now unclarified. As always with Bosch, however, there is satisfying refuge to be taken in the

100

recognition of psychological mood. · In *The Temptation*, Saint Anthony remains solid and unmoved by the overwhelming phantasmagoria of evil beckonings. This says much for the strength of the faithful soul—but what of the world itself? Countless enactments of destructive human folly continue in the very midst of a profound demonstration of faith. Fire, always a potent religious and literary symbol, was in Bosch's day particularly connected with the religious and folkloric conceptions of Saint Anthony. Ultimately, popular interpretations of Anthony as the guardian against diseases placed fire as chief among the weapons he used to exorcise maladies. By perverse extension, he was often invoked more for his destructive than curative powers, a not unusual result of medieval saint cultism. Fire in this work (central panel) is perhaps a background reinforcement of the spiritual ineffectiveness of human-induced holocaust. Despite the underlying pessimism of the triptych, there is a sense of energetic hopefulness born of the sheer endurance of the saint and of Bosch's own concern to exorcise the demons of sin from humanity's frenzied unconscious.

20–24. *The Last Judgment*

Oil on wood 163.0 × 125.4 cm (central panel) 163 × 61 cm (side panels) Academy of Fine Arts, Vienna

Bosch received the commission to paint this triptych from Philip the Handsome of Burgundy in 1504. But whether or

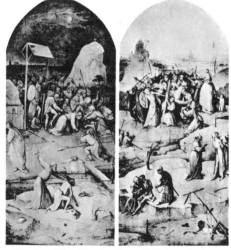

Bosch *The Temptation of Saint Anthony* (with panels closed) *Circa* 1500

not this is the original is in some doubt. Merciless fantasies unfold in dazzling array, but they are not so composed as to reveal a clear direction. The head-and-legs *gryllus* figure, a Bosch favorite, makes several appearances (see also *The Temptation of Saint Anthony*, central panel), and there are areas of brilliant color work and foreshortening technique that speak of Boschian vigor. However, the painting as a whole has more the overtone of an imitation than of the real thing. (For a *Last Judgment* believed to be part of the Bosch original, see Plate No. 31.)

25–30. *The Garden of Delights*

Circa 1500 Oil on wood 220.2 × 195.1 cm (central panel) 220.2 × 96.9 cm (side panels) Museo del Prado, Madrid

Bosch's largest work, this triptych presents sin and sinners as fantastically beautiful captivations rather than as the more traditionally rendered horrors of some of his own previous works and those of other painters of the day. Juxtapositions that create delightful puzzles at first glance can yield often comic moral "stories" after a little thought, even to the un-initiated. This is not to say, however, that the core of mystery informing the profusion of diverse figures—all apparently acting out some part of a cryptic symbolic scheme—can ever be rightly interpreted. But the beauty of any work of art, however mysterious, is that it can stimulate a whole chain of "messages" to the mind of the observer, touch the realm of

dreams and fancies that is common to every human being. And this is what *The Garden* does and what keeps it a gorgeous, tempting enigma for all ages of man. The central panel, for instance, is a veritable tapestry of lust, gaily colored and set in the vertical pattern of medieval tapestries. Opposed in tone to both this and the left panel is the somberness of the right, its blues and greens compounding the silent atmosphere of a hell dedicated to forced excesses of the senses as punishment. But even here the nonsensual, delicate eroticism is not betrayed. In a way, *The Garden* is a more successful moral instruction, however complex, than the direct indictments of sin in other Bosch works (*The Haywain*, for instance), because it presents sin as an enticement rather than as a glorification of ugliness that none but the most depraved would seek. It is, in a word, real. Sin is temptingly beautiful, after all, and this triptych is Bosch's recognition of that fact.

31. Fragment of a *Last Judgment*

 1504? Oil on wood 60 × 114 cm Alte Pinakothek, Munich

(See notes for Nos. 20–24.)

32. *The Prodigal Son*

 Wood 72.6 cm (diameter) Boymans-Van Beuningen Museum, Rotterdam

A version of this figure is found in *The Haywain* when its

panels are closed (see illustration, p. 100), but it is less developed in theme and has a rather bland, almost casual quality. On the other hand, this *Prodigal Son*, also known as *The Hawker*, demonstrates Bosch's restrained mastery at its best. Much of the soulful appeal of the wandering figure lies in his melancholy nostalgic expression—a mood that is reinforced by the almost monochromatic palette, which Bosch has chosen to apply to surrounding nature as well. True to form, the artist has gone beyond depicting a simple Biblical tale to a broader, albeit mysterious, level of meaning.

33 & 36. *The Flood: Noah's Ark* and *The World of Evil*

Grisaille on wood diptych 70.0 × 38.4 cm (each panel) Boymans-Van Beuningen Museum, Rotterdam

34 & 35. *The Flood: Biblical Parables*

(reverse side of above diptych)

There is some speculation that this work may once have been a triptych, perhaps especially because of the unclear connection between the ark scene and *The World of Evil*. In fact, some scholars feel that Hell, and not the world, is the subject.

37. *The Temptation of Saint Anthony*

Circa 1515 Wood 70.8 × 51.7 cm Museo del Prado, Madrid

The subtle modulation of color tones is one of the chief

104

Bosch *The Human Tree*

differences between this and the Lisbon *Temptation* (Nos. 15–19). Also note the absence of graphically drawn temptations; the latter are suggested instead by somewhat surrealistic figures, outward signs, perhaps, of Anthony's inner visions of torment. This work belongs to a later phase of Bosch's artistic evolution.

38. *Saint John the Baptist in the Wilderness*

 Wood 50.0 × 40.6 cm Museo Lazaro-Galdiano, Madrid

There is some suggestion that this painting was perhaps the left panel, and *Saint John the Evangelist in Patmos* (No. 11) the right, of a triptych whose center panel was lost. The typically Boschian synthesis of dream world and real is reinforced by the strange, sinister-looking thistle in the foreground. Its fruit is, in fact, poisonous, as the bird lying dead beside it confirms.

39–40. *The Bearing of the Cross*

 Circa 1505 Oil on wood 74 × 81 cm Musée des Beaux-Arts, Ghent

Except for the beam of the cross that runs diagonally from Christ to the upper-left-hand corner, like a sharp ray of light, the entire surface of this work is covered with faces. Christ, with the peace of death already in his face, appears at center and again in the lower left corner in Veronica's veil. Veronica herself is the only person in the crowd who seems mindful

105

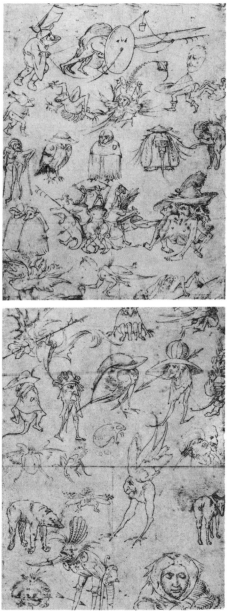

(top) Bosch *Study of Monsters* (detail)
Bosch Reverse side of *Study of Monsters* (detail)

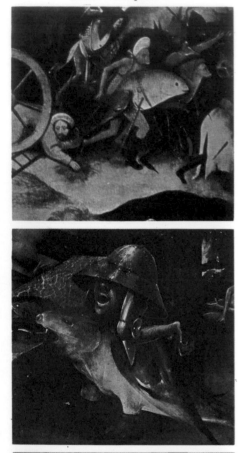

of what is happening to Jesus. The array of faces seems almost like a collection of masks of cruelty, inspired, as some scholars have suggested, by those worn in the religious processions of Bosch's day. And yet the overriding potency of expression— in eyes bulging in anticipation of the cruelties to come, and in mouths open to reveal toothless, decaying blackness—precludes any idea of masks. These are faces of people enlivened by the horror of the moment, and by the hope of having their privately imagined tortures come true. This work ranks with Bosch's greatest; it is a thoughtfully planned and executed drama set in the most economical and challenging of backdrops: black space.

41. *The Temptation of Saint Anthony*

63 × 82 cm Private collection, Amsterdam

Compare Nos. 15–19 and 37 with this work, which is generally not counted as a Bosch original.

Pieter Bruegel (Circa *1525-1569*)

42 44. *The Battle between Carnival and Lent*

 1559 Oil on wood 118.0 × 164.5 cm Kunsthistorisches Museum, Vienna

The fat man astride a wine barrel and holding a spitted pig perhaps best illustrates the frantic feasting and carousing spirit of the pre-Lent period; the thin figure, lower right, quite obviously personifies the self-denial of the Lenten season. The contrast had obvious appeal for Bruegel, the satirist. It is one of the artist's earliest *Wimmelbilder,* that is, "a picture swarming with people."

45–47. *The Netherlandish Proverbs*

 1559 Oil on wood 117 × 163 cm Staatliche Museen, Berlin

This encyclopaedic painting contains more than a hundred proverbs, maxims, rhymes and symbols. Some amuse, others shock, and still others are today quite obscure in meaning. A brief sampling will give the idea. The two men seen in the second-story window, deeply engrossed in pulling each other's noses while another man is stealing a look at their cards (No. 46), express motifs that often appear in medieval tales of foolishness: "Fools get the trump cards"; "They lead one another by the nose." The man bent over the table (lower

107

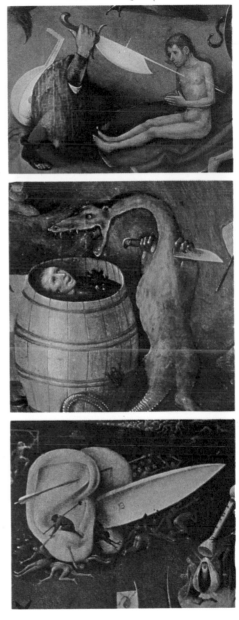

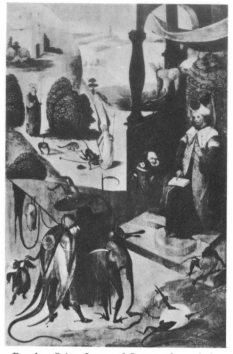

Bosch *Saint James of Compostela and the Magician*

right) cannot reach from one loaf to the other, that is, he "cannot make ends meet." And finally, the man holding an eel (upper right) demonstrates that an eel "held by the tail is not yet caught."

48–50. *Children's Games*

> 1560 Oil on wood 118 × 161 cm Kunsthistorisches Museum, Vienna

The village square is the scene of another of Bruegel's *Wimmelbilder*; in this case more than 200 children are scattered about like fireworks, playing games. The fact that more than eighty contemporary children's games are recorded here is an interesting comment on the instincts of an artist working in the dawn of the art of printing. Because of the serious expressions on the faces of the children—much like adults absorbed in their various occupations—some scholars feel that Bruegel was presenting a microcosm of human life in general.

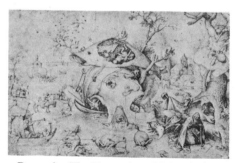

Bruegel *The Temptation of Saint Anthony*

51–52. *The Fall of the Rebel Angels*

> Oil on wood 117 × 162 cm Musées Royaux des Beaux-Arts, Brussels

The battle between the Archangel Michael and the rebellious Lucifer, as told in the Apocalypse of Saint John, has been a popular subject for numerous artists. One of the earliest examples is the top of the left wing of Bosch's *Last Judgment* (Nos. 20–24), which is thought to have influenced Bruegel.

108

53. *The Suicide of King Saul*

1562 Oil on wood 33.5 × 55.0 cm Kunsthistorisches Museum, Vienna

This is one of Bruegel's works that were inspired by the Old Testament. It is an interesting example of a trend in the so-called Northern painting of the time toward focusing on the anecdotal aspects of Biblical incidents. The composition of the valley and the soldiers has the force and power of a scene from an Eisenstein film; but in contrast, on a cliffside (at left), Saul and his servant are quietly facing death by their own hand. (Saul, already wounded in battle, thrust a sword through his throat to punish himself for the sin of pride.)

54–56. *The Triumph of Death*

1562 Tempera and oil on wood 117 × 162 cm Museo del Prado, Madrid

The unsettled political climate of Bruegel's time made death an almost daily expectation. At any moment some king or sultan might send a conquering horde of merciless invaders to the tempting Low Countries. It is not surprising that such a preoccupation engendered various artistic expressions, one of which was a series of woodcuts on the theme of dying nobly. The idea was to inspire even the humblest soul to meet death with the pious acceptance of a saint. In this painting, the grim reassurance that death, the great leveler, comes to king and peasant alike is brought home in imaginative,

109

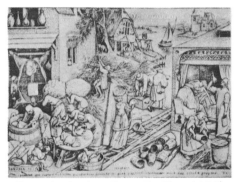

Bruegel *Big Fish, Little Fish* 1556

Bruegel *Prudence* (from *The Virtues*) 1560

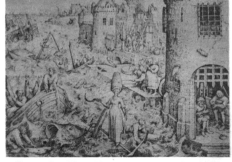

Bruegel *Hope* (from *The Virtues*) 1560

gruesome detail. Death seems to have prevailed over an entire village at once, interruptive, impatient, totally overwhelming.

Bosch Panel of *The Last Judgment* triptych (detail)

57. *Head of an Old Peasant Woman*

Circa 1568 Oil on wood 22 × 18 cm Alte Pinakothek, Munich

Though this painting is of a single individual—the only such by Bruegel known to exist—it cannot be truly called a portrait. A woman has been characterized according to type rather than according to a particularizing set of details about her personality. Bruegel's early preference for depicting types rather than individuals had its most obvious expression in the studies from life (*naer het leven* drawings), examples of which are given on p. 111.

58–59. *The Tower of Babel*

1563 Oil on wood 114 × 155 cm Kunsthistorisches Museum, Vienna

With his typical dazzling simplicity of brushwork, Bruegel executes a great number of detailed work-in-progress situations and converts them into a single powerful study of human endeavor. There is another Bruegel *Tower of Babel* in the Boymans-Van Beuningen Museum in Rotterdam (see

p. 112). Different from the Vienna painting, King Nimrod and his entourage do not appear, and the tower is much nearer completion.

60. *The Carrying of the Cross*

 1564 Oil on wood 124 × 170 cm Kunsthistorisches Museum, Vienna

In another brilliant example of his ability to present a whole picture that can be broken down into several complete compositions, Bruegel blends quotidian events with Biblical drama. The windmill atop the rock (top left center) was a common device used by painters to create a "cosmic landscape." As Bruegel has used it here, it is perhaps more noticeable than effective.

61. *The Dark Day*

 1565 Oil on wood 118 × 163 cm Kunsthistorisches Museum, Vienna

The cosmic landscape is beautifully exemplified in this painting, one of a series that Bruegel did to depict the flow of seasons. *Dark Day* was the first, for in sixteenth-century Europe the calendar year began in March.

111

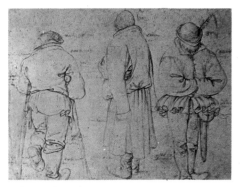

Bruegel *Three studies,* (at left) a cripple (at right) a soldier After 1560

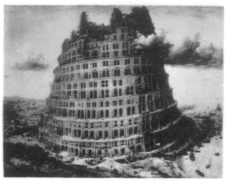

Bruegel *Tower of Babel*

62. *The Harvesters*

> 1565 Oil on wood 118.0 × 160.7 cm Metropolitan Museum of Art, New York

A proper cosmic landscape depicted a distant, imagined background view as seen from a highly placed foreground scene. As this and the following two plates demonstrate, Bruegel's seasons series made him the first of the great landscape painters.

63. *The Return of the Herd*

> 1565 Oil on wood 117 × 159 cm Kunsthistorisches Museum, Vienna

64. *The Hunters in the Snow*

> 1567 Oil on wood 52 × 78 cm Alte Pinakothek, Munich

65. *Land of Cockaigne*

> 1565 Oil on wood 117 × 162 cm Kunsthistorisches Museum, Vienna

This painting supposedly depicts the sluggard's transient dream of Paradise, and thus focuses on the deadly sins of gluttony and sloth. The three men sprawled out asleep under

the table are a knight, a peasant, and a scholar, identified by the lance, the hoe, and the book, respectively.

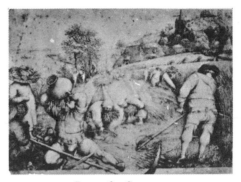

Bruegel *Summer*

66. *Numbering at Bethlehem*

> 1566 Oil on wood 116.0 × 164.5 cm Musées Royaux des Beaux-Arts, Brussels

Of the many artists who popularized this Biblical incident, Bruegel was the first to add the tax-collecting scene (at far left). Whatever political motives may have been operating in Bruegel's mind (Spanish tax collections—and executions were at that time part of everyday Flemish life) are exceeded in the long view of art history by the importance of his contribution to the freeing of Biblical subjects from their typical holy settings, blending them instead into the humble activities of daily life.

67. *Massacre of the Innocents*

> 1566 Oil on wood 116 × 160 cm Kunsthistorisches Museum, Vienna

Bruegel's contemporizing of a Biblical story, again depicted here, beautifully preserves the religious significance while adding an ironic dimension—a ploy that links the artist's work to modern realism.

113

68–69. *The Peasant Dance*

Circa 1567 Oil on wood 114 × 164 cm Kunsthistorisches Museum, Vienna

Whole Flemish villages turned out to celebrate the feast day of the local patron saint. Just such a *kermesse*, as it was called, was most likely the inspiration for Bruegel's recording brush. This painting represents a late phase in the evolution of the artist's vision. Compared with his earlier *Wimmelbilder*, it demonstrates a change in point of view and a closer, more studious portrayal of individuals rather than types. For an interesting comparison, see *The Battle between Carnival and Lent*, Nos. 42–44.

70. *Peasant Wedding*

1568 Oil on wood 114 × 163 cm Kunsthistorisches Museum, Vienna

Bruegel's detailed richness of vision provides both precious records of sixteenth-century Flemish life and gorgeous displays of sharply rendered, realistic vignettes that pose questions and invite pleasant scrutiny to find answers. For instance, who is the bridegroom in this painting?

71. *The Peasant and the Birdnester*

1568 Oil on wood 59 × 68 cm Kunsthistorisches Museum, Vienna

"He who knows where the nest is," so the Flemish saying

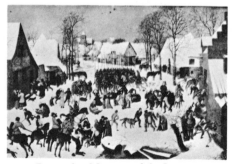

Bruegel *Massacre of the Innocents*

114

goes, "has the knowledge, but he who robs it has the nest." In this illustrated proverb, Bruegel reveals three of the most typical of his painting subjects: proverbs, peasants and landscape.

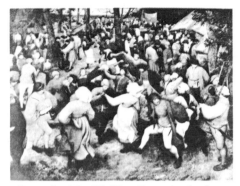

Bruegel *The Wedding Dance in the Open Air* 1566

72. *The Conversion of Saint Paul*

1567 Oil on wood 108 × 156 cm Kunsthistorisches Museum, Vienna

On orders from King Philip of Spain, the Duke of Alba led an army of 20,000 men from Madrid to Brussels—via ship and the Alps, an inconvenient route necessitated by the poor relations between France and Spain. Finally arriving in Brussels in August of 1567, he immediately set up the so-called Council of Blood for the investigation of heresy and treason, which action confirmed the worst imaginings of the Dutch and Flemish citizens. The alpine setting for this painting is thus generally seen as the Duke's route. There is an additional similarity between the Duke himself and Saul (his name before conversion): both were cruel persecutors of Christians. It is tempting to conclude that this was a politically motivated work, though nothing about Bruegel's political feelings has been validated. Just as tempting a persuasion in another direction is the fact that the artist had made an alpine crossing of his own fifteen years before, when he traveled to Italy. Perhaps his memory of the staggering beauty of that mountain landscape motivated this sublime tribute to it. For the scenery, and not Paul, is after all the real focus of the painting.

115

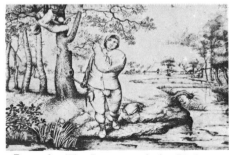

Bruegel *The Peasant and the Birdnester* (drawing)

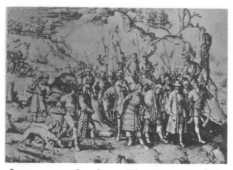

Lucas van Leyden *The Conversion of Saint Paul* 1519

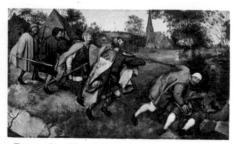

Bruegel *The Blind Leading the Blind* 1568

73. *The Cripples*

1568 18.0 × 21.5 cm Louvre, Paris

Bearing out Bruegel's fascination with groups of cripples and beggars is this small panel. There are at least two possible readings. One is that the pain-toughened, pitiful figures symbolize the price of sin—for Bruegel's contemporaries believed that a crippled body denoted erring ways. The second possibility is that Bruegel took inspiration from a group of his compatriots, political rebels who called themselves "The Beggars" and wore foxtails and chains, traditional emblems of mendicants. These dissident noblemen agitated against Spanish dominance and were the seeds of a rebellion that grew eventually into a war of independence.

74. *Storm at Sea*

Oil on wood 70.3 × 97.0 cm Kunsthistorisches Museum, Vienna

In this richly painted comment on the power of nature, even the whale that threatens the ship seems a weak challenge in the face of the storm itself. The crew has thrown a barrel overboard in an attempt to divert the whale, but it is merely a pitiful gesture. This is one of the last of Bruegel's works.

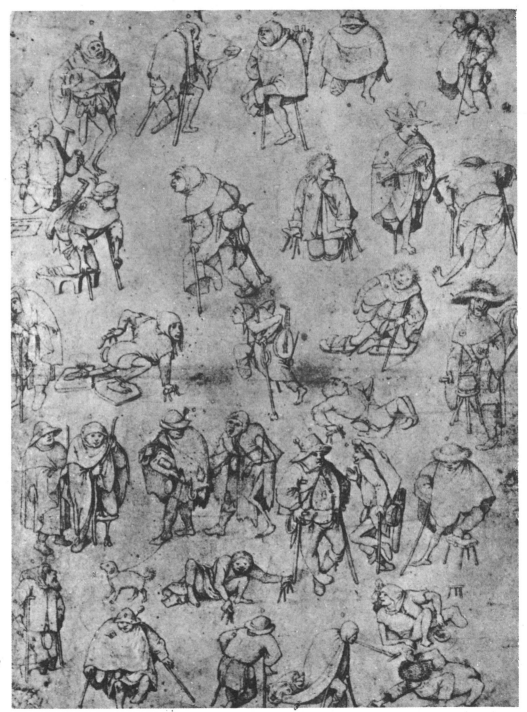

Bruegel *Study of Cripples*

CHRONOLOGY

Bosch / Bruegel	Date	General
	1440	Gutenberg begins experiments with printing.
Bosch born in 's Hertogenbosch.	1450	
	1452	Production begins on forty-two-line Bible.
	1470	Mathias Grünewald born in Wurzburg, Bavaria.
	1471	Albrecht Dürer, German painter and engraver, born.
Bosch marries probably this year.	1480	Albrecht Altdorfer born.
	1485	War of the Roses ends.
Bosch paints altarpiece for chapel of Saint John's Cathedral.	1489	Hans Memling paints *Legend of Saint Ursula*.
	1494	Lucas van Leyden, Netherlands painter and engraver, born. Sebastian Brant's *Ship of Fools* published.
	1496	Desiderius Erasmus, Dutch humanist, born in Rotterdam.
	1497–98	Hans Holbein born.
Bosch receives commission for *The Last Judgment* from Philip the Handsome of Burgundy.	1504	
	1508	Lucas Cranach court painter to the Electors of Saxony.
Bosch designs furnishings for the chapel of the Brotherhood of the Holy Virgin in 's Hertogenbosch.	1511	
	1513	Grünewald begins the Isenheim altarpiece.
Bosch dies. Grand funeral in his honor held in the Brotherhood chapel.	1516	Charles I begins reign as king of Spain.
	1519	Charles I becomes Holy Roman Emperor, Charles V.

	1520	Dürer travels in the Netherlands.
	1521	Martin Luther completes his German translation of the New Testament.
	1524	Peasants' War begins in Germany.
Bruegel born.	1525	
	1528	Dürer dies. Grünewald dies.
	1535	Imperial decree issued in Brussels for the suppression of heretics.
	1536	Erasmus dies.
	1537	François Rabelais publishes *Gargantua*.
	1538	Altdorfer dies.
Bruegel becomes apprentice of P. Coecke van Aelst.	1540	
	1543	Holbein dies.
	1545	Council of Trent opens.
	1546	Luther dies.
Bruegel a master of the Antwerp Guild.	1551	
Bruegel travels to Italy.	1551–1552	
	1553	Cranach dies.
Bruegel contracts with printseller, Hieronymous Cock, to do drawings for engravings.	1555	Charles V abdicates. Son Philip begins rule.
Bruegel's *Seven Deadly Sins* prints published.	1558	Charles V dies.
Bruegel paints *The Netherlandish Proverbs*.	1559	Religious persecutions in Spain.
Bruegel marries Marie Coecke, daughter of P. Coecke van Aelst. Moves to Brussels.	1563	First Calvinist religious convention held in the Netherlands.
Pieter Bruegel (the Younger) born.	1564	Calvin dies.
	1566	The Calvinists organize a Citizens' League.
	1567	The Eighty Years' War begins.
Jan Bruegel (the Elder) born.	1568	
Bruegel dies.	1569	

LIST OF COLOR PLATES

LIST OF ILLUSTRATIONS